The 20th Century
at the Courtauld Institute Gallery

The 20th Century

at the Courtauld Institute Gallery

First published to accompany *Into the Twentieth Century,
New Displays at the Courtauld*, October 2002

The new displays are supported by donations from
Nicholas and Jane Ferguson and Nicholas and Judith Goodison

Published by the Courtauld Institute Gallery,
Courtauld Institute of Art

Distributed by Paul Holberton publishing through
Greenhill Books, 1 Russell Gardens, London NW11 9NN
www.greenhillbooks.com

Produced by Paul Holberton publishing
37 Snowsfields, London SE1 3SU
www.paul-holberton.net

ISBN 1 903470 08 0

Designed by Philip Lewis

Printed in Italy

Cover image: Detail, Robert Delaunay, *The Runners*, 1924–25 (see page 76)
Title page: Detail, Alexei Jawlensky, *Dunes at Prerow*, 1911 (see page 48)
Page 6: Detail, Fernand Léger, *Contrast of Forms*, 1913 (see page 70)

Preface

The Courtauld Institute of Art is delighted to be able to extend its collections further into the twentieth century as a result of these very generous loans of over one hundred outstanding works of art. Our warmest thanks go to the lenders for helping us to achieve this milestone in our development, and to all those who have been involved in bringing it to fruition. These magnificent additions to our family of collections will further enhance the Institute's distinguished teaching and research work, and the public's enjoyment of our Gallery.

2002 has been a wonderful year for the Courtauld Institute of Art. Established in 1932, the Courtauld became an independent college within the University of London on 1 August 2002. We achieved the top rating in the most recent Research Assessment Exercise and the work of the Gallery was similarly recognized by the Arts and Humanities Research Board. The arrival of these collections followed soon afterwards. Our next major step is the development of new galleries in the South Building of Somerset House, which will provide new space for the display of the growing nineteenth- and twentieth-century collections, including those described in this handbook.

Nicholas Ferguson
Chairman

Foreword

Samuel Courtauld's reputation as a connoisseur rests on his achievement in assembling the brilliant collection of Impressionist and Post-Impressionist paintings which bears his name. Yet he was a modest man, who thought deeply about society and its needs, and the collection was never conceived as standing on its own. From 1923, the year in which he began buying pictures seriously on his own account, he was also guiding and prompting the directors of the National and Tate Galleries in the spending of a large sum of money which he had given in order to transform the national collections of European art. He wanted to show how the great tradition of European painting since the Italian Renaissance had been renewed by the 'Impressionist Revolution' of the 1870s, and how the art of painting might again in the twentieth century answer the human need for beauty and spiritual meaning in life.

Courtauld's vision was therefore essentially historical, dependent in the case of the national collections on a sense of causal continuity which links the art of the past to the present and to the future. In the case of his own collections and the house in Portman Square which he established as a memorial to his wife after her death in 1932, he always hoped that his pictures would be joined by other gifts and bequests, and would thus declare his own belief in art as a living force, open and exploratory in form and significance. Events have more than justified his hope: since the bequest of Roger Fry in 1934, the enlightened philanthropy of successive collectors has enriched the displays of the Courtauld Institute Gallery so that they balance and amplify the national collections, and constitute a resource for teaching in the history of art which has come to be of indispensable value.

And yet, especially since the re-arrangement of the collections in Somerset House in 1990, it has been obvious that they, and the space available, give only a hesitant account of the developments in European art after 1900. Cézanne has been there in strength, together with late Renoir and a famous Modigliani, but Courtauld's early Picasso, implicitly the pendant of his Modigliani, is on loan to the National Gallery, and there is no Matisse. With hindsight, it seems curious that Courtauld, who clearly responded strongly to 'pure' painting – the use of colour to express emotion and insight into the nature of apprehended reality – should not have acquired (or retained) any painting by Matisse, the leading spirit of the revival of 'pure' painting in the early years of the twentieth century. From Matisse's example the Fauves sprang, and it seems as certain as anything could be that Courtauld, like Fry, would have understood not only their lineage from Matisse, but the dependance of every cross-current in Expressionism or Cubism on exactly that revival of the art of painting which the emerging orthodoxy of Modernism traced back to the 1870s, to Degas, Manet, Cézanne, Gauguin and Van Gogh.

But now, as the Gallery faces the next stages in its growth, that is changing. With the new displays outlined in this book, the twentieth century is no longer the almost-missing or abbreviated consequence of everything so insistently predicted by our collections up to 1900. For the first time the Gallery is able to show historically coherent groups of works representing key developments in the art history of the early twentieth century, with concentrations, as in the case of Kandinsky, of exceptional strength in depth. Unlike the national collections, the Courtauld does not divide its account of early Modernism at 1900: the fact that the creative continuities between, say, Gauguin, Van Gogh, Matisse and Derain can now be seen at the Courtauld without that artificial hiatus is therefore of very real benefit to the whole pattern of London's great art museums.

It is hard to pick out individual works from the new displays for special mention, but Matisse's *Red Beach* and Derain's *Fishermen at Collioure,* which mark the birth of Fauvism in 1905, will certainly prove to be among the most important new presences from the point of view of the teaching of the Institute. Derain's *The Dance* is similarly a key work, a wonderful image to come upon as a fulfilment, as it were, of the promise of Gauguin's *Te Rerioa.* A comparable relationship exists between the group of Vlamincks and the Courtauld's Van Goghs. The angular *Boats at Martigues,* one of several important Dufys, similarly illustrates the significance of Cézanne in the development of early twentieth-century painting. Delaunay's marvellously dynamic *Runners* is a picture that would hold the attention of the visitor to any major museum of Modern art. Léger's *Contrasts of Forms* also deserves special attention. Since it is otherwise poorly represented in London, the new displays of early twentieth-century German art are particularly welcome and significant. Pechstein emerges powerfully with *Women at the Sea* of 1919, as does August Macke. The group of sixteen works by Kandinsky is of exceptional quality and provides a remarkable account of the stylistic evolution of this pioneering figure over more than thirty years. The work of Kandinsky's close associates Gabriel Münter and Alexei Jawlensky is also represented, the latter richly illustrating Jawlensky's boldly expressive use of colour and interest in abstraction.

One of the most exciting aspects of the new display, however, is the increased presence of sculpture. Degas's *Little Dancer aged Fourteen* is frequently cited as having had a similar effect on the public in 1881 as Manet's *Déjeuner sur l'herbe* had in 1863, and a significant group of small bronzes of human and animal figures, caught in the midst of movement, introduces sculptures by Rodin, Renoir, Matisse and Maillol that explore the same formal vocabulary, and link obviously with paintings and pastels already in the collection. Especially welcome are the pieces by Laurens, Archipenko, Moore and Hepworth, which

further enable the Gallery at last to give some account of sculpture in the early twentieth century.

These developments, which amount to a transformation in the range and visual power of the Courtauld's displays, have necessitated the re-organization of the second floor of the Gallery, so as to increase the total amount of wall space and create a sequence of rooms for the orderly experience of the histories that we are recounting. In fact, the new spaces and their sequence are extrapolated with some logic from the arrangement of the floor below, but there is in this, undeniably, a short-term aesthetic loss. Our hope is that the immense public benefit of the new displays will reconcile those primarily interested in the architecture of William Chambers to this temporary intrusion on his noble design. For it is, shortly, the Institute's intention to develop new galleries in the South Building of Somerset House, and to restore Chambers's Great Room to its original form and use as an exhibition space. The new displays, covering that whole period from the mid nineteenth century into the twentieth, will then be deployed with proper space and light in the new sequence of rooms.

Fundamental to this is the fact that, with the works of art shown here, the Courtauld Institute Gallery moves on to a new level of public importance. As ever, this is owed to the vision and generosity of private collectors. One of the phenomena of changing art historical under-standings over recent years has been the re-evaluation of the Fauve 'moment' of 1905–07 as the first flowering of Modernism, perhaps, despite its brevity, more enduring in its effect of liberating painters from the academic tradition than either Cubism or Expressionism. The directors of the Fridart Foundation, especially through their policy of lending freely to international exhibitions, have been influential in this evolving understanding. Other collectors with whom we have been privileged to work include Roger Emery, whose Kandinskys make such an impact in the new display, and the Wilson Family Trust, which has, for us, a particularly relevant interest in German art and the painters influenced by Gauguin. To all these and to others, including Lillian Browse and the sponsors of the new displays, the Courtauld Institute extends its thanks for their friendship as well as their generosity. It has been observed that the Courtauld is in some sense like a family, and that the Gallery remains 'a collection of collections'. It is indeed our hope and our determination that we shall remain both of these things, and that our continued growth should always be on that principle.

Courtauld Institute Gallery
September 2002

CONTRIBUTORS

SB Shulamith Behr

HB Helen Braham

AD Ann Dumas

SF Simonetta Fraquelli

JH John House

BM Benjamin Morse

JM John Murdoch

CP Catherine Pütz

JT Jessie Turner

EV Ernst Vegelin van Claerbergen

The 20th Century

at the Courtauld Institute Gallery

PAUL CÉZANNE
(1839–1906)
The Turning Road
(Route tournante)
ca. 1904–05

oil on canvas 73 × 93 cm
Bequeathed as part of the
Princes Gate Collection, 1978

The site represented in *The Turning Road* has not been identified. It has been suggested that it is a scene near Cézanne's last studio, on a hill on the northern edge of Aix-en-Provence called the Colline des Lauves. However, it may well be from northern France; Cézanne was painting near the Fontainebleau forest, to the south-east of Paris, in the summer of 1905. The flatness of the landscape depicted and the comparatively muted colour suggest a northern site, in contrast to the rocky landscapes around Aix and the stronger colour-contrasts by which Cézanne expressed the effects of the southern light.

Although it is one of his largest landscapes, *The Turning Road* is a very lightly worked picture, with large areas of light-toned primed canvas left unpainted. In the second half of his career Cézanne abandoned many canvases at a similarly early stage of their execution, when in conventional terms they were clearly unfinished. However, he considered even some of his most highly worked paintings to be in some sense unsatisfactory and incomplete, while there are unfinished areas in many paintings that he seems to have felt to be fully resolved. We cannot tell why Cézanne did not continue to work on this painting.

The turning road in the foreground is indicated only by a number of rapidly painted linear indications, and the lie of the land in the centre of the picture remains unclear. Our eye can read a progression into space across the sequence of horizontal bands of coloured strokes, which suggests fields and hedges, but the detail is nowhere clear, and the path taken by the road further into the landscape is not indicated. The treatment of the church spire emphasizes the sense that the rendering of forms is provisional: the additional outline to the right of it was presumably added as a prelude to a reworking that Cézanne never completed.

Although by nineteenth-century standards the picture would have appeared unresolved, the lack of conventional finish in Cézanne's late paintings such as *The Turning Road* was a powerful inspiration for many artists in the twentieth century, in their search for an expressive personal style that rejected academic rules. In contrast to the loose finish of the picture, the subject is conventional, with a village in the distance dominated by a church spire, and the composition framed on the left by a pair of trees.

The Turning Road was acquired by the dealer Ambroise Vollard presumably directly from the artist or from the artist's son soon after Cézanne's death; it remained with Vollard until 1937, when it was bought by Sir Kenneth (later Lord) Clark, then Director of the National Gallery, London. In 1941 Clark sold it to Count Antoine Seilern, owner of the Princes Gate Collection.

HB & JH

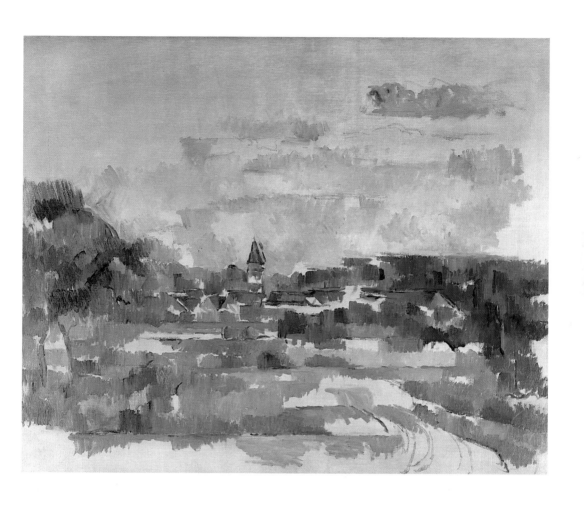

PIERRE-AUGUSTE
RENOIR (1841–1919)
Portrait of Ambroise Vollard
1908

Signed top left *Renoir 08*
oil on canvas 81.6 × 65.2 cm
Courtauld Gift, 1932

The young Ambroise Vollard met Renoir around 1895 and became one of the principal dealers in his work. He was also the organizer of the first exhibitions of Cézanne's work, from 1895 onwards, and one of the pioneering dealers who bought the work of the Fauves, commissioning Derain's views of London in 1906 (see page 28), and buying up the contents of both Derain's and Vlaminck's studios.

Vollard commissioned portraits of himself from many artists – from Cézanne, Picasso, Bonnard and others. Renoir's is one of the least acute of these, either as a record of the dealer's bulldog features or as an evocation of his cunning, quirky personality. Rather, Renoir made his picture into an image of the archetypal connoisseur, appreciatively holding a statuette, in the tradition of the collector portraits of the Italian Renaissance. The painting also evokes the dealer's power over the sensuous image of a woman that he holds in his hands and in his gaze; his pudgy fingers closely resemble the limbs of the statuette.

The statuette he holds is by Aristide Maillol, the *Crouching Woman* of 1900, apparently in its original plaster form. At around this date Maillol, at Vollard's request, visited Renoir to execute a portrait bust of the painter, and the inclusion of the piece by Maillol may refer to this. Moreover, the simplified, monumental classicism of Maillol's sculpture may well be relevant to the development of Renoir's art during these years. In the 1890s, he had looked in particular to the Rococo painters of the French eighteenth century, but after 1900 he adopted a broader treatment and a more monumental type of composition and modelling – a sort of timeless classicism. This development is apparent in the firmly modelled, rounded treatment of the figure in the *Portrait of Ambroise Vollard*, distinctly separated from its surroundings. Such treatment is in contrast to his work of the 1870s, when he largely abandoned black in favour of modelling suggested by the play of colour alone. In the 1890s he re-adopted modelling in black and grey, partly as a result of his studies of the techniques of the Old Masters; thereafter he insisted that black was a colour of prime importance in his palette. In this portrait, the comparatively monochrome treatment of the jacket, enriched only by a few coloured nuances on the folds, is set off against the warmth of the flesh and the background. In contrast to his earlier work, blue is sparingly used, appearing only at a few points, on the tablecloth and in the pottery on the table.

JH

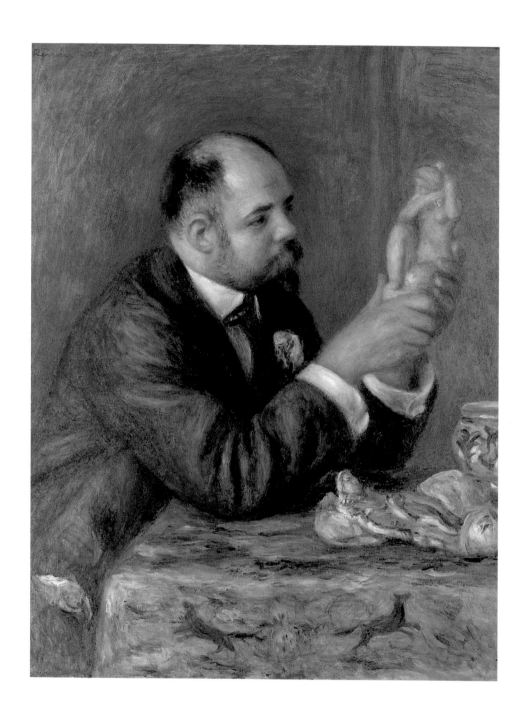

15

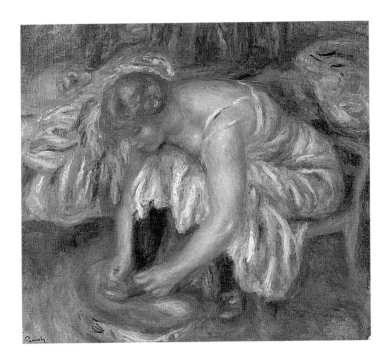

PIERRE-AUGUSTE
RENOIR (1841–1919)
*Woman at her Toilet
(Femme faisant sa toilette)*
ca. 1918

Signed lower left *Renoir*
oil on canvas 50.5 × 56.5 cm
Courtauld Gift, 1932

One of the first French paintings bought by Samuel Courtauld, this canvas was probably executed in 1918 at Cagnes, near Nice on the Mediterranean coast, where Renoir had built himself a house. His move to the South coincided with his abandonment of contemporary scenes in favour of seemingly timeless subjects, in which he emphasized the form of the figures, looking back to past painting, to Titian and Rubens.

In his last years, he painted many images of women at their toilette. These monumental, inexpressive figures express his view of women's rôle in society – as creatures of nature, practical and physical, in contrast to the male world of intellect and 'culture'. Here the details are unspecific: this is not a figure of fashion, but rather a simple country woman. The technique emphasizes the physicality of a woman's world; the figure dominates the composition, with bold ribbons of paint modelling her petticoat and threads of colour enriching the flesh, and her surroundings are handled in lavish swirls of colour. The rich warm colour evokes the idea of the South as a health-giving region where, Renoir said, "It seems as if misfortune cannot befall one".

JH

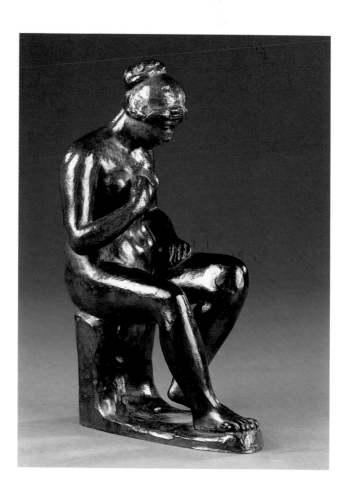

ARISTIDE MAILLOL
(1861–1944)
*Seated Woman (Femme
assise)* 1902

cast no. 3 in an edition of 6
bronze, height 26 cm
Private collection

Maillol's wife was the model for *Seated Woman*. In its harmony and
sense of repose, the piece evokes antique prototypes. Yet, compared to
later works, the monumental *La Mediterrannée* of 1905, for example,
in which the forms are reduced to grand, simplified volumes, *Seated
Woman* is relatively naturalistic, especially in the features of the face.
An earth-bound movement flows down from the inclined head to
the left hand resting on the thigh, through the massive legs and feet.
A gentle, upward counterforce is established by the raised right hand
with which the model touches her breast. In complete contrast to
Rodin's dancer (page 18), Maillol's figure is weighty, still and filled
with a noble *gravitas*.

Maillol was a versatile artist, a painter, tapestry designer and
illustrator, but after 1900 he concentrated exclusively on sculpture,
although he remained a prolific draughtsman. His subject was
predominantly the female nude. Like Cézanne in his late paintings of
monumental female bathers, Maillol sought to find a modern equivalent
for classical tradition, in his case the great sculptures of antiquity.
At the same time, in their heavy sensuality, his female nudes have an
earthiness that has been felt to evoke the Mediterranean peasant.
AD

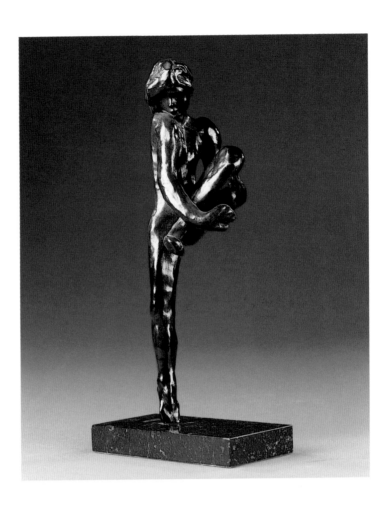

AUGUSTE RODIN
(1840–1917)
*Study of Dance Movement:
Dancer with Raised Knee
(Etude de mouvement de
danse) ca.* 1910–11

bronze, height 32.2 cm
Fridart Foundation

This little dancer is full of energy and grace. She clasps her left leg, bending it high and close to her chest. The upper body is a dense and compact mass of intertwining curves with arms stretched down, hands clasped, shoulders hunched, head turned and the face pressed into the right shoulder. The extended and tensile right leg is the focus of the piece and the single element that gives it its gravity-defying *élan*.

Rodin is generally considered to be the greatest sculptor of the nineteenth century. He achieved an emotional and erotic range that was completely new. He is best known for his monumental pieces *The Age of Bronze, The Kiss, The Burghers of Calais* and *The Gates of Hell*. But the dancers, which began to preoccupy him around 1908, represent a private, experimental side of his work. He studied the movements of famous dancers such as Nijinsky, Isadora Duncan and Loïe Fuller, whom he invited to perform in his studio. The hundreds of little figurines he made in order to explore the kind of unconventional pose demonstrated here suggest a fascinating parallel with Degas, who also made many statuettes of dancers for his own private study. In both cases, the figurines were cast in bronze after the artists' deaths.

AD

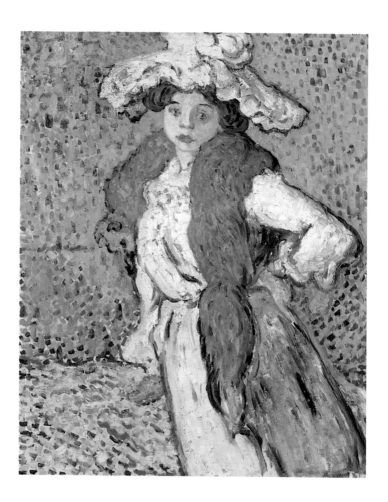

LOUIS VALTAT
(1869–1952)
Portrait of Mme Valtat
ca. 1904

oil on canvas 100 × 81 cm
Fridart Foundation

Of an older generation than most of the Fauves (see following pages),
Louis Valtat was only loosely associated with the group, exhibiting with
them from time to time. He studied with the Nabi painters Bonnard
and Vuillard (see pages 66–68), and was a friend of Toulouse-Lautrec.
He also worked with Aristide Maillol (see page 17) on some of his
earliest sculptures.

In 1900 Valtat married Suzanne-Charlotte Noël and settled at Agay
in the Midi. This resplendent portrait of Suzanne demonstrates how
he successfully fused a number of contemporary artistic trends into a
vigorous and personal style. The figure's striking pose, her *belle époque*
flamboyance, with just a hint of caricature, recalls Lautrec. Valtat's
palette, although heightened and brilliant, was always, unlike that of
the Fauves, tied to natural appearances. In this portrait, the figure
emerges from a dense tapestry of dabs, dashes and squiggles in a
vibrant but subtle mix of predominantly grey-greens and pinkish-
mauves with a dash of orange – revealing the lessons Valtat learned
from the Neo-Impressionists, especially Signac.
AD

HENRI MATISSE
(1869–1954)
*The Red Beach
(La Plage rouge)* 1905

signed lower left *Henri Matisse*
oil on canvas 33 × 40.6 cm
Fridart Foundation

At the end of the summer of 1905, which Matisse had spent working with Derain in the Mediterranean fishing village of Collioure (see page 24), he mentioned "the little unimportant things" he had painted there, adding that, nevertheless, they succeeded in "expressing his sensations in a very pure way". Their collaboration pushed both Matisse and Derain to use colour with unprecedented audacity and brilliance and to apply paint with a raw immediacy, exposing every mark on the unprimed canvas with all the informality of a sketch.

The daring innovations of that summer are vividly demonstrated in *The Red Beach*. A startling vermilion beach dominates the foreground, a striking example of colour used for expressive and purely visual rather than descriptive ends. As Matisse explained, 'In reality [the beach] was yellow sand, but I realised I had painted it red. I tried it yellow the next day. It didn't work at all, so I did it red again." Broad slashes of paint in complementary greens and reds indicate the boats, enhanced by a sizzling cacophony of pinks, oranges, mauves and violets applied in shorter, dabbing and curling strokes that raise the chromatic pitch. Despite Matisse's desire to reject academic rules, *The Red Beach* displays an innate, and sophisticated, structure. The solid foreground is beautifully counterbalanced by the airy expanse of sea in which loosely painted blocks of lilac-pink interspersed with turquoise float over a white-primed ground and suggest both waves and glittering light. The division between these compositional zones is marked by a row of diagonally slanting masts that provide an elegant screen through which we view the distant, high blue horizon and a lemon-yellow headland enlivened along its base with broad dabs of orange-red, of which the function is chromatic rather than descriptive.

When works similar to *The Red Beach* were displayed at the Salon d'Automne of 1905, critics were astonished by the intense colours and rough handling and nicknamed the artists '*fauves*' (wild beasts). In reviews that echo the reactions that had greeted the first Impressionist paintings thirty years before, critics were puzzled by the works' sketchiness, their lack of finish. The dazzling colour seemed crude to some, though others appreciated the Fauves' "orgy of pure tones".

Matisse, however, always insisted that Fauvism was not just about colour: "That is only the surface," he said; "what characterized Fauvism was that we rejected imitative colours and that with pure colours we obtained stronger reactions – more striking simultaneous reactions; and there was also the *luminosity* of our colours". The expressive and decorative power of colour that Matisse discovered at Collioure would lay the foundation for all his future work.

AD

HENRI MATISSE
(1869–1954)
*Woman in a Kimono
(Femme au kimono)*
ca. 1906

signed lower right *Henri
Matisse*
oil on canvas 31.5 × 39.5 cm
Private collection

The model for *Woman in a Kimono* is Matisse's wife Amélie Parayre,
who is recognizable from her high cheek bones and strongly arched
eyebrows. Matisse often painted his wife in exotic costume, and
throughout his career he would enrich still-life and figure subjects
with richly patterned fabrics. Amélie in her kimono captured the
imagination of other Fauve painters working in Matisse's circle. Derain
painted a powerful portrait of her, *Woman with a Shawl* (formerly
private collection, Paris) in 1905. The same year both Camoin (see
page 37) and Marquet (see page 35) painted her wearing the kimono
as she sat making a tapestry version of Derain's portrait, an object she
entered in the Salon des Indépendants in 1905.

After the superbly assured Fauve paintings of 1905 (see previous
page) Matisse seemed to be less sure of his direction, working in the
following year simultaneously in different styles. He explored Gauguin's
zones of flat colour and arabesque contours, as in *Joy of Life* (*Le
Bonheur de vivre*, 1905–06; Barnes Foundation), yet was not ready to
relinquish the varied, lively touch of the previous year. Patches of
resonant blues, greens, reds and ochres convey the pattern of the
fabric in *Woman in a Kimono* and, with the economy of means that
would be a hallmark of Matisse's mature work, a few deft red marks
suggest a shutter.

AD

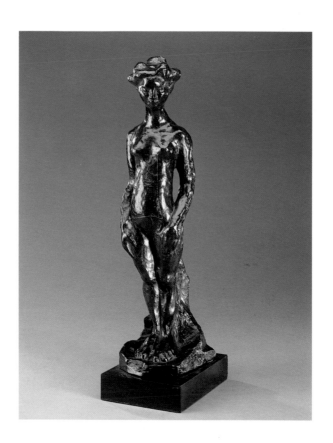

HENRI MATISSE
(1869–1954)
Standing Nude
(Nu debout) 1906

bronze, height 49.5 cm
Fridart Foundation

Standing Nude, for which Matisse's daughter Marguerite modelled, conveys a curious blend of grace and awkwardness. The carriage of the head, long neck, sloping shoulders, long arms extended down the sides of the body and torso, thrust forward in a slightly serpentine curve, are unified by an elegance of line that contrasts with the foreshortened, almost squat legs and massive feet. In its stasis *Standing Nude* represents a radical departure from his more naturalistic earlier sculptures, which is largely a result of Matisse's enthusiasm for African sculpture, one shared by Picasso as he developed his ideas for *Les Demoiselles d'Avignon* of 1907. In *Standing Nude,* the size of the head, large in proportion to the body, the thrusting belly, and the hands clamped to the body are features of African sculpture. In addition, the figure's verticality and its feeling of containment suggest general affinities with different kinds of archaic sculpture, Cycladic for example, or the pre-Roman Iberian sculpture which Matisse saw at a Louvre exhibition in the spring of 1906. More than half Matisse's entire production in sculpture (sixty-nine works) was made in the early part of his career, between 1900 and 1909. But, as he explained, "I sculpted as a painter. I did not sculpt like a sculptor." Sculpture, for him, was a way of stepping back, reflecting and re-considering issues that had emerged in his paintings. The little sculptures of these years often make an appearance in those paintings.

AD

ANDRÉ DERAIN
(1880–1954)
*Fishermen at Collioure
(Pêcheurs à Collioure)*
1905

signed lower right *a derain*
oil on canvas 46 × 56 cm
Private collection

Derain spent the summer of 1905 in the south of France painting with Matisse (see page 20) in the small Mediterranean fishing village of Collioure, a few miles from the Spanish border. Both artists had already experimented with brilliant, unmodulated colour applied with vigorous, loose touches of paint, but their collaboration in Collioure was the catalyst from which sprang the fully fledged Fauvist style in all its exuberance. The paintings they produced that summer caused a sensation at the Salon d'Automne of 1905 and earned the artists the name that has stuck, '*fauves*' or 'wild beasts'.

On this, his first stay in the south, Derain was bowled over by what he described in a letter to Vlaminck as "the blond, golden light that suppresses shadows". He explained that his new way of painting was "a new conception of light which consists in this: the negation of shadow. The light here is very strong, the shadows very luminous. The shadow is a whole world of clarity and luminosity which contrasts with the light of the sun." Derain and Matisse were exhilarated by the discovery that they could avoid tonal divisions and use intense colour to throw off light. In *Fishermen at Collioure* the deep aquamarine shadows cast by the fishermen pulling in their nets are just as solid as the men themselves. Every element in the painting is given equal weight. The sea is a dense blue and the reflected light scattered over its surface is rendered with little red bricks of paint. A dominant area of beige canvas flecked with dabs of pinks, soft reds and whites acts as foil to the boats painted with larger, thicker strokes in bold, almost crude red, yellow and blue, demonstrating the "deliberate disharmonies" that Derain sought.

Matisse likened himself and Derain working at Collioure to "children in the face of nature". The quest for a child-like and spontaneous vision was very much part of the Fauves' intention and is evident not only in the colours used in *Fishermen at Collioure* but also in its deliberately naive composition. The unusually high viewpoint reduces the composition to broad, simplified zones, and the figures are described with a few summary strokes of the brush. Van Gogh was a major inspiration to Matisse and Derain as they forged a style based on immediacy, strong colour contrasts and a vigorous technique.

The innocence, freshness and seeming crudeness of the Collioure paintings baffled critics at the time, who judged them puerile, but it is these very qualities that have ensured the works' enduring appeal.
AD

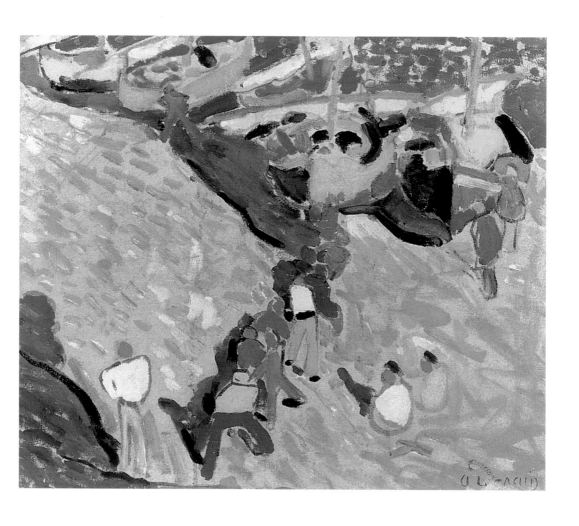

ANDRÉ DERAIN
(1880–1954)
The Dance (La Danse)
ca. 1906

oil and distemper on canvas
185 × 228.5 cm
Fridart Foundation

A group of figures perform a primitive dance in a jungle setting. The orange-hued bodies glow against indigo vegetation and a citron sky – vivid, anti-naturalistic colours that are typical of Derain's Fauve palette. Two female dancers occupy centre stage, one nude and the other clothed in a flowing garment with stripy drapery which establishes the cursive rhythm that flows through the entire composition, animating everything from the striped trees with their writhing branches to the convoluted green snake. A seated nude, a graceful, dancing figure, a richly plumed bird and, at lower left, a spiteful little demon with a cloven tail and phosphorescent eyes complete the scene.

Almost a hundred years after it was made, this large painting has lost none of its magnetic strangeness. Painted probably in 1906, *The Dance* was Derain's most ambitious painting to date and a significant new departure in his work, away from informal outdoor scenes towards monumental figure compositions. *The Age of Gold* (1904–05; Museum of Modern Art, Teheran) and *The Dance* show Derain exploring, albeit in a more strident tone, the timeless, mythical world of Matisse's Arcadian idylls *Luxe, calme et volupté* (1905; Musée d'Orsay) and *Joy of Life* (*Le Bonheur de vivre*, 1906; Barnes Foundation).

The Dance is an extraordinary blend of diverse visual sources that shows just how experimental and sophisticated Derain was as a young artist, responding to the many artistic stimuli fermenting in Paris during this unusually creative period. One can detect the pantomime animals and phantasmagorical forests of Henri Rousseau's home-grown jungle scenes. But paramount in Derain's new-found exoticism was the influence of Gauguin, whose work was much in evidence in Paris after his death in 1903, above all in the retrospective at the Salon d'Automne in 1906. The frieze-like composition of *The Dance* and its brilliant, arbitrary colour are clearly indebted to Gauguin's Tahitian paintings; so is the suggestion of a Christian narrative, in this case the Fall of Man and the theme of good and evil with its traditional symbolism of the fruit tree and the serpent.

The drapery patterns of the clothed figure's robe have been likened to Romanesque carvings. More specifically, the pose of the nude dancer is a direct quotation from the figure of *Isaiah* on the Romanesque portal at Souillac in south-western France. The dancing figure at the right is reminiscent of the black servant in Delacroix's *Women of Algiers* in the Louvre, although it also evokes the Indian relief carvings that Gauguin admired. The mask-like features of the draped dancer resemble an African mask that Derain acquired from Vlaminck. Derain's next major figure composition, *The Bathers* (1907; private collection) reveals a new influence, Cézanne, a direction that would lead him away from Fauvism and ultimately toward the conservatism of his later years.

AD

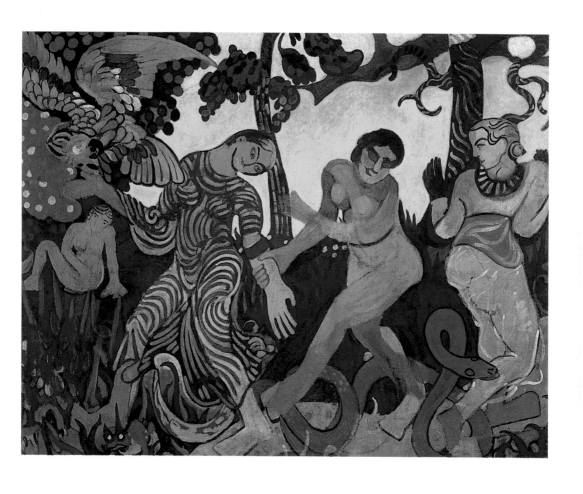

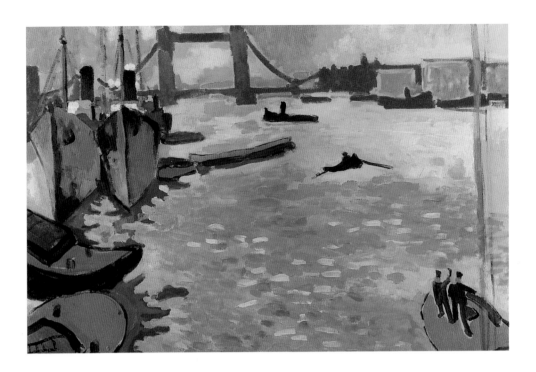

ANDRÉ DERAIN
(1880–1954)
*The Thames and Tower
Bridge (La Tamise et Tower
Bridge)* 1906

signed lower left A. *Derain*
oil on canvas 66.5 × 99 cm
Fridart Foundation

Derain spent a few months in London in 1906, after a probable
earlier visit the previous year. The reason was a commission from
the enterprising art dealer Ambroise Vollard (see page 14) to paint a
series of views of the Thames. Vollard, who had bought up the contents
of Derain's studio in 1905, was inspired by the highly successful
exhibition of Monet's London paintings at the Durand-Ruel gallery in
1904. Monet had painted an extended series of views of the Thames
and its bridges during three painting campaigns from 1899 to 1901.

It is a measure of Derain's confidence as a young artist that he
was able to produce a vivid and entirely individual group of paintings
that owe little or nothing to the example of his illustrious predecessor.
Monet loved the way London's mists and fogs enveloped the city in
subtle veils of light. Derain's brilliant palette, on the other hand, is
autonomous and bears little relationship to the actual light and weather
of London, but succeeds in capturing the animation of the commercial
waterway. In *The Thames and Tower Bridge* the drama of the composition
springs from its boldly asymmetrical design, its chromatic intensity and
the assured handling of paint. The fiery Turneresque sky establishes
the key for a brilliant scheme based on the complementary hues of red
and green. The dominant expanse of empty water is enlivened by a
chromatic sequence from light blue through aquamarine to a golden
sunburst on the right.

AD

ANDRÉ DERAIN
(1880–1954)
The Park at Carrières-Saint-Denis 1909

oil on canvas 54.1 × 65 cm
Gift of the Roger Fry Trustees,
1935

In the summer of 1909 Derain and Georges Braque stayed together at Carrières-Saint-Denis, now Carrières-sur-Seine, near Argenteuil on the outskirts of Paris. A seventeenth-century park designed by André Le Nôtre survives there and is presumably the setting for this scene, with its formal rectangular pond in the centre. The uneven surface of the picture is due to underpainting, apparently of a different composition.

The dark tonality comes as a surprise after the brilliant colours of Derain's Fauve paintings of 1905–07. Derain now places great emphasis on simple defined areas of flat colour. He shared with Braque an intense interest in Cézanne and even the choice of subject appears to be a legacy of Cézanne's images. Braque painted a scene similar to Derain's at Carrières but in a more explicitly Cubist style.

Roger Fry bought this work at the celebrated first Post-Impressionist exhibition in 1910. Derain became a favourite artist of Fry's and this picture seems to have had a significant effect on Fry's own style.
HB

MAURICE DE
VLAMINCK (1876–1958)
Reclining Nude (Nu couché) 1905

oil on canvas 27 × 41 cm
Private collection

This vigorously painted nude is typical of Vlaminck's Fauve style. The handling of paint over the entire canvas is varied and lively, ranging from a textured weave of brushstrokes in the red area at lower left to spots of yellow that float over the variegated background of dark and light blues, to an area of sharp green that acts as foil to the warm-toned body, to the energetic streaks of thick white paint in the sheet (Vlaminck claimed that he squeezed his paints direct from the tube).

The gusto of Vlaminck's paintings was matched by his life. He had ambitions to be a professional cyclist; he played the violin in Parisian *cafés-concert*, and he was a prolific writer. For Vlaminck the painter, the decisive influence on his early career was his meeting with Derain, with whom he shared a studio in the Parisian suburb of Chatou from 1900 to 1901. Through Derain he met Matisse and was exposed to the new and brilliant use of colour that these artists developed in Collioure in the summer of 1905 (see pages 20 and 24). He exhibited with them at the notorious Salon d'Automne of 1905, when all the artists acquired the derisive nickname '*Fauves*' (wild beasts). Of equal impact on his early development was a major exhibition in 1901 of the work of Van Gogh, which confirmed the emotional intensity and direct expression of Vlaminck's own artistic persona.

Like Kees van Dongen (see page 46), Vlaminck painted the cabaret entertainers of Montmartre. The model in this painting resembles a number of portraits that he made of a dancer at Le Rat Mort, a popular night-club. She is stretched out in a seductive pose, and splodges of red, blue-green and white paint humorously exaggerate the girl's heavy make-up in a way that brings to mind Picasso's paintings of similar Montmartre subjects.

AD

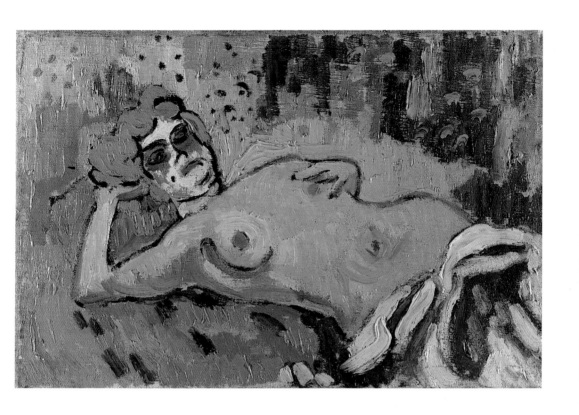

MAURICE DE
VLAMINCK (1876–1958)
*Banks of the Seine at
Carrières-sur-Seine
(Bords de la Seine à
Carrières-sur-Seine); also
known as Spring Sun –
Banks of the Seine (Soleil
de printemps – bords de
la Seine)* 1906

signed lower centre *Vlaminck*
oil on canvas 54 × 65 cm
Private collection

The suburban landscape along the Seine around Vlaminck's native Chatou to the northwest of Paris provided him with endless visual stimulation and a wealth of motifs. He rarely travelled elsewhere. Like *Fisherman at Argenteuil* (page 34), *Banks of the Seine* is an autumnal landscape. A brilliant blue unites sky and water, suffusing the entire scene with the radiance of an Indian summer day. The blue provides a luminous backdrop for the red trees, the branches of which crackle with an electric force across the surface of the canvas, creating a fiery screen through which we view the white houses on the distant bank. Vlaminck was painting with Derain in the autumn of 1906 and the red trees that recur in his Seine views follow the example of the landscapes Derain had painted in L'Estaque that summer. The composition is informal. The river bank – a rough, unpicturesque piece of ground – dominates the immediate foreground, but the bold placing of the trees infuses the whole composition with a sense of drama and excitement.

A deep sense of place and of the nurturing power of nature remained fundamental to Vlaminck and was central to his profound identification with Van Gogh; so also was the untrammelled energy of his brushstrokes, with their persistent broken and animating rhythm. Like Van Gogh, Vlaminck was keen to promote his reliance on instinct and individuality. "You have to go it alone, to count only on yourself, follow your instinct and the natural laws", he claimed. However, as with *Fisherman at Argenteuil*, the legacy of the Impressionists' Seine views is inescapable – in this case those of Monet and also of Sisley, who painted a number of autumnal riverside landscapes. Although Vlaminck pushes colour and handling to a greater extreme of intensity than the Impressionists ever did, in the immediacy of his response to landscape and the expressive force of the touch – the artist's mark – he remains true to their principles.

The years 1906 and 1907 were of extraordinary productivity for Vlaminck. In April 1906, the dealer Ambroise Vollard (see pages 14 and 28) bought up Vlaminck's studio, freeing him from the need to work as a part-time violinist and allowing to him to devote himself completely to his painting. The result was an astonishing flow of creative energy and a remarkable series of landscapes. After 1907, Vlaminck, like many of the other Fauves, submitted to the influence of Cézanne. Thereafter his work displayed a new sense of structure and moderation, but the brilliance and intensity of his high Fauvist years was never recaptured.

AD

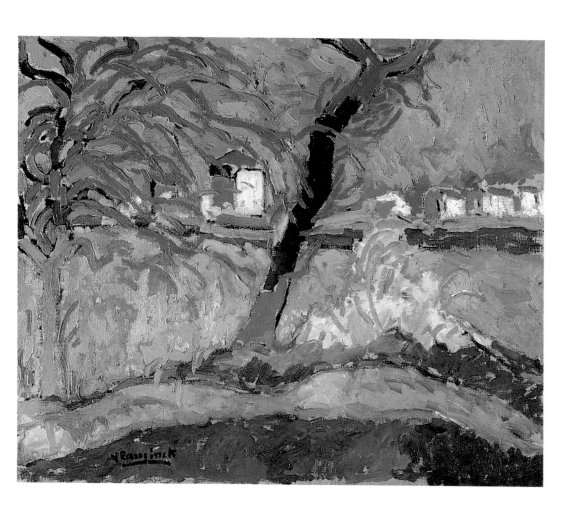

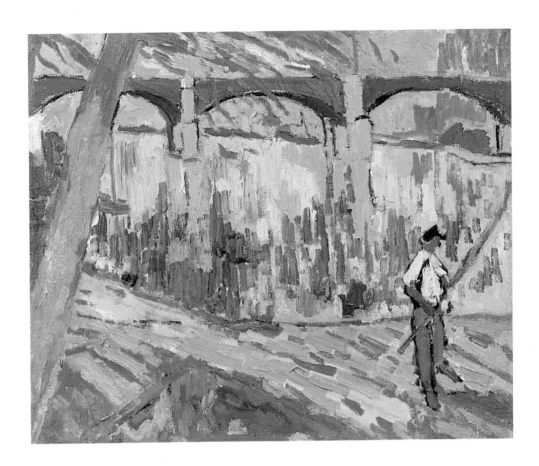

MAURICE DE
VLAMINCK (1876–1958)
*Fisherman at Argenteuil
(Pêcheur à Argenteuil)*
1906

oil on canvas 45.5 × 55 cm
Private collection

Vlaminck loved the suburban landscape to the northwest of Paris along the Seine. Argenteuil was one of the leisure-spots that had been colonized by the Impressionists in the 1870s. Although Vlaminck's highly developed sense of his artistic individuality made him reluctant to acknowledge other artists' precedence, Monet's classic Impressionist views of Argenteuil of 1872–74, with the river bank prominent in the foreground and the familiar iron bridge arching across the skyline, surely lie behind Vlaminck's composition. But while Monet peopled his riverside views with elegant, bourgeois strollers, Vlaminck's left-wing sympathies led him to favour more proletarian figures, such as the solitary fisherman here.

The glowing reds and golds that resonate against the cooler tones of the water in *Fisherman at Argenteuil* suggest an autumn scene. The canvas vibrates with a variety of vigorous, stabbing marks of the brush that describe the reflections dancing on the water, a building to the right, the rough texture of the bank, and the branches arching out over the water. Despite the chromatic intensity of his paintings, Vlaminck never worked in the south of France, but learned from Derain's experiments with colour on the Côte d'Azur. He worked with him in the autumn of 1906, on his return from L'Estaque in the south.

AD

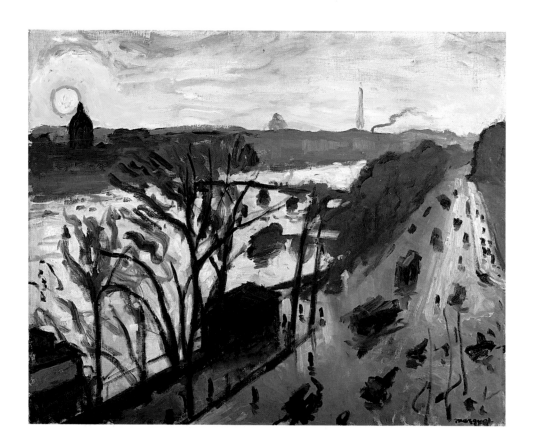

ALBERT MARQUET
(1875–1947)
The Quai du Louvre 1905

signed lower right *Marquet*
oil on canvas 65 × 80 cm
Fridart Foundation

Marquet painted numerous panoramic views of Paris. This sweeping view of the Seine at sunset on a winter's day brings to mind Pissarro's series of Parisian views looking down on the city from a hotel window, painted just a few years before. The indistinct bulk of the Louvre is visible on the right. Through a screen of vigorously painted bare, wintry trees we see the Eiffel Tower on the distant skyline. To the left the yellow, orange-ringed dome of the Institut de France suffuses the vast sky with a burst of golden light that dissipates in streaks of grey and pink and contrasts with the metallic, silvery greys of the river and the Quai du Louvre.

In the studio of Gustave Moreau Marquet became friends with Manguin (see page 36), Camoin (see page 37) and especially Matisse (see page 20), who took the shy, retiring Marquet under his wing. They developed a close working friendship. Painting together regularly from around 1892 for about a decade, they experimented with new methods and techniques, for example bringing a new colouristic intensity to the Neo-Impressionists' broken brushwork. But Marquet, like his friends Camoin and Manguin, held back from full-blown Fauvism. Instead, he developed a latter-day Impressionist technique in which he displayed a special sensitivity to nuances of light and tone that can recall Corot's quiet sensibility.

AD

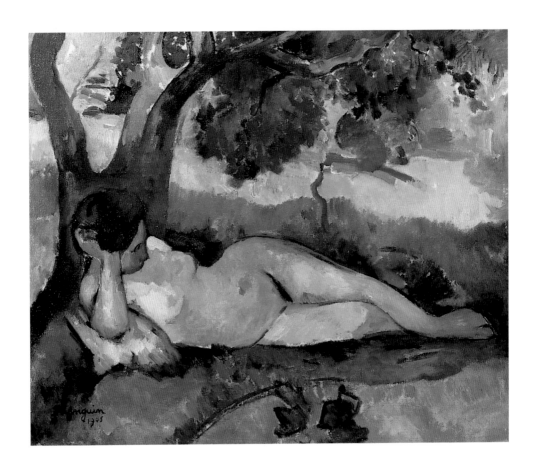

HENRI MANGUIN
(1874–1949)
*The Siesta (Jeanne
reclining under the Trees)
(La Sieste (Jeanne couchée
sous les arbres))* 1905

signed and dated lower left
Manguin 1905
oil on canvas 50 × 61 cm
Private collection

Reviewing the Fauves at the Salon d'Automne of 1905, the critic Louis Vauxcelles referred to Camoin, Marquet and Manguin as "a flock of migrating birds who had gone in search of the *pays enchanté* of the south". Saint-Tropez on the French Riviera, which Manguin discovered thanks to his friend Paul Signac in 1905, did indeed become his 'enchanted country'. In this work Manguin gives us the classic subject of the nude in a landscape. His wife Jeanne reclines in a radiant, lush setting. The composition is based on a melodious balance of warm and cool tones built up over the canvas in a dense patchwork of short parallel strokes that is clearly indebted to Cézanne. Bands of glowing, interwoven pinks, oranges and golds contrast with a darker blue-green area that casts a cool light over the warm tones of the flesh. Manguin never adopted the vivid dissonant colour or aggressive technique pursued by Matisse and Derain in 1905. Till the end of his life his paintings were based on a harmonious blend of Impressionism and Cézanne that proved popular with middle-class patrons.

AD

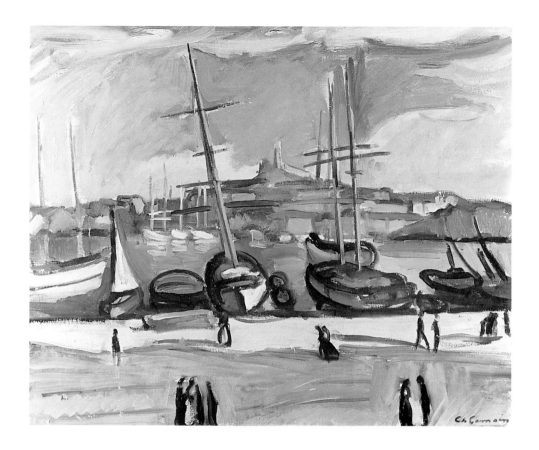

CHARLES CAMOIN
(1875–1965)
*Port of Marseilles (Port de
Marseille)* ca. 1904–06

signed lower right
Ch. Camoin
oil on canvas 73 × 93 cm
Private collection

Although his name is often associated with the Fauves, Camoin
himself claimed that he did not recall having been one. He was
connected with the Fauve artists through personal association and
had studied with Matisse, Marquet and Puy in Gustave Moreau's
studio but, fundamentally, he did not share their aims. His mission,
he felt, was to perpetuate the principles of Impressionism, and his art
was always rooted in recording what he saw. His luminous, naturalistic
palette has little in common with the bold autonomous colour
employed by Matisse, Derain and Vlaminck. Camoin greatly admired
Cézanne and the two artists met and corresponded, but Cézanne's
influence on Camoin`s work is limited.

Between 1904 and 1906 Camoin often travelled with Manguin and
Marquet along the Côte d'Azur. In this, one of four similar views of
the port of his native Marseilles, Camoin looks across to the fort on the
opposite hill. Bold outlines and a supple, vigorous handling create a
sense of energy and immediacy. The pervasive Mediterranean blue is
punctuated by the vivid oranges and greens of the boat and lighter
pinkish streaks in the sky and along the quay.

AD

EMILE-OTHON FRIESZ
(1879–1949)
La Ciotat 1907

Signed lower right
Othon Friesz
oil on canvas 65 × 80 cm
Fridart Foundation

Friesz spent the summer of 1907 at La Ciotat, a coastal port south-east of Marseilles, with his friend Georges Braque. There the two artists created a distinctive brand of decorative Fauvism, the culmination of the style for both of them. Friesz was struck by the high, rounded hills around La Ciotat and in this work renders them schematically with a pinkish-red, arabesque line, establishing an abstract rhythm comparable to Braque's soft, undulating contours (see page 40). Horizontal bands of pink, yellow, red and green in the middle ground, echoed by separate staccato strokes predominantly in oranges and violets, balance the bounding line. The fiery orange-red tree at the right is extremely simplified. Friesz's iridescent, high-keyed palette dominated by acid yellow-greens and modified with blues and mauves is close to the golden tones, pinks and reds that Braque was employing at the same time. Loose, swirling strokes in a thinish paint allow the buff-coloured canvas that Friesz favoured to show through.

Friesz, like Braque and Dufy, came from Le Havre. The son of a prosperous shipowner, he attended the local art school before winning a scholarship to study at the Ecole des Beaux-Arts in Paris. Like other Le Havre artists, Friesz was influenced by the local tradition of *plein-air* landscape painting and his early work is in an Impressionist tradition. In Paris Friesz was in regular contact with Matisse and the other Fauves and, like them, absorbed the influences of Van Gogh, Gauguin, and Cézanne. The works by Matisse and Derain that Friesz saw at the autumn Salons of 1905 and 1906 opened his eyes to the expressive potential of colour. "Colour," Friesz remarked, "was our saviour." For the next two years Friesz worked in a distinctive manner using brilliant, sometimes shrill colour. The works produced at La Ciotat in 1907, however, display a more harmonious palette and a new concern with structure. That autumn he moved away from Fauvism and turned to the inspiration of Cézanne, an inspiration that would be confirmed, as it was for many artists in Paris, by the major Cézanne retrospective at that moment. Friesz explained that Cézanne, combined with the natural structure of the Provençal landscape, took him in a new direction. "Colour ceased to be the mistress of the canvas, design was reborn amid volumes and light." After 1908 Friesz abandoned Fauvism and worked in a rather conventional, modern classicizing manner for the rest of his long career. In the 1910s and 1920s he was a prominent member of the School of Paris, a popular teacher, and he enjoyed a considerable international reputation.

AD

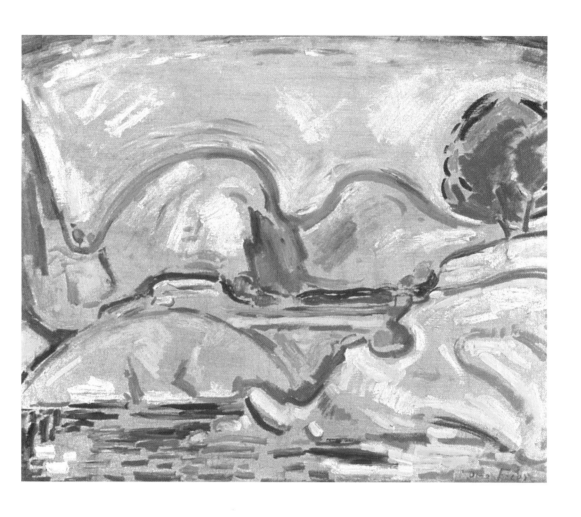

GEORGES BRAQUE
(1882–1963)
Port of L'Estaque (Port de L'Estaque) 1906

Signed and dated lower left
G Braque o6
oil on canvas 46 × 55 cm
Private collection

Braque, the youngest of the Fauve group, first visited L'Estaque with his friend Friesz (see page 38) in October 1906, staying until February the following year. The little town on the edge of Marseilles is the subject of some of Cézanne's most structured and elegiac paintings of the early 1880s. Braque's admiration for Cézanne was undoubtedly a major factor in his decision to go to L'Estaque, although he claimed that good weather and cheap accommodation were also factors.

In *Landscape at L'Estaque* Braque adopts a position to the west of Marseilles that Cézanne had also chosen. The subject also recalls Matisse's harbour views painted the year before at Collioure in 1905 (see page 20). But whereas Matisse's entire canvas bursts with the reckless energy of arbitrary colour Braque's palette, though strong, is comparatively serene and contained. The near and far boats described in strong primaries – red, yellow and green, enlivened with pinks and greys – float in the broad expanse of sea, sky and distant hills, painted in a weave of softly modulated pastel tones. Braque's concern is indeed harmony rather than dissonance. The plenitude of forms and calm, glowing colours suggest a response to Matisse's *Joy of Life* (*Le Bonheur de vivre*, 1905–06; Barnes Foundation) shown at the Salon des Indépendants in the spring of 1906, rather than the more discordant works of 1905.

Braque pursued brilliant Fauve colour in the more intense canvases painted at La Ciotat on the Mediterranean the following year. But for him the Fauvist adventure was short-lived. In 1908 he explained, "I knew the paroxysm it contained could not go on forever. How? When I returned to the south of France for the third time, I noticed that the exaltation that had filled me during my first stay there and that I transmitted to my paintings was not the same any more. I saw that there was something else."

Braque was essentially a northern painter. He grew up in Le Havre, where he met Friesz and Raoul Dufy (see pages 38 and 42). After 1929 he divided his time between Paris and Varengeville-sur-Mer on the Normandy coast. Dazzling light and emotive distortions were not, in the end, what interested him. Rather, he sought the balance and harmony between things. Braque's true individuality would emerge in the muted sobriety of the great Cubist still lifes that grew out of his collaboration with Picasso from 1909 to 1911, and the rich yet sombre still lifes and interiors of his later career.

AD

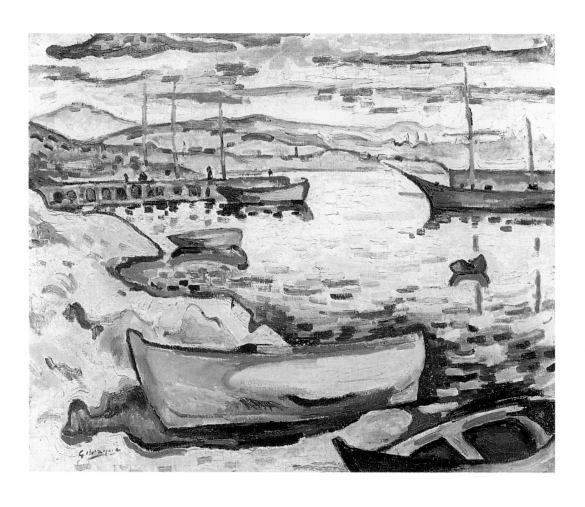

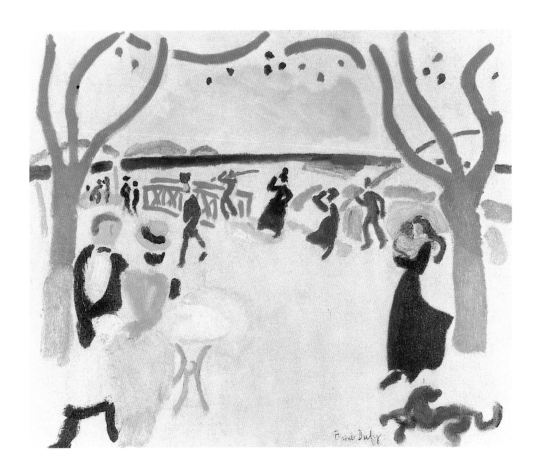

RAOUL DUFY
(1877–1953)
The Passers-by
(Les Passants) ca. 1906–07

signed lower right *Raoul Dufy*
oil on canvas 46 × 55 cm
Private collection

With a few deft lines of the brush in luminous pastel shades of lemon, pink, pistachio and blue, Dufy conjures a witty little sketch of holiday-makers at Trouville or Sainte-Adresse, probably during the summer of 1906 when he was working on the Normandy coast. One or two social vignettes and an amusing dog occupy the foreground, while further back a few figures brace themselves against a stiff sea-breeze and hold on to their hats. The wide expanse of bare, white-primed canvas fills the scene with sparkling seaside light. Two quite unreal, orange-coloured trees frame the view and perhaps poke fun at the formality of classical landscape composition.

Dufy's early work was influenced by the strong tradition of outdoor landscape painting in his native Le Havre, and also, of course, by the Impressionists. But in 1905 the impact of seeing Matisse's *Luxe, calme et volupté* (1905; Musée d'Orsay) caused him to redirect his art completely. The arabesque line and brilliant, non-naturalistic colour he now discovered were perfectly attuned to his own exuberant vision of a modern paradise of worldly pleasure. In *Passers-by*, the calligraphic brush drawing and bright colour are clearly indebted to Matisse's early masterpiece, but the caricature-like figures also suggest an affinity with the graphic work of Bonnard and Vuillard.

AD

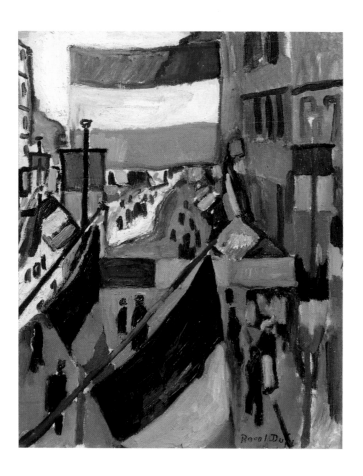

RAOUL DUFY
(1877–1953)
*14 July at Le Havre (Le 14
Juillet au Havre)* 1906

signed lower right *Raoul Dufy*
oil on canvas 46.5 × 38 cm
Fridart Foundation

Dufy spent the summer of 1906 with his friend Albert Marquet (see page 35) painting along the Normandy coast at Trouville, Honfleur and in his native Le Havre. Dufy's gift was to capture the gaiety of modern life. He painted the colourful posters on view in Le Havre that summer, and it was natural that he should be attracted to the festive spectacle of the streets of Le Havre decked out with flags for the 14 July celebrations. Flags, with their broad bands of bold colour, were a natural subject for the Fauves and, indeed, the number of flag paintings on view at the Salon d'Automne that year attracted critical comment.

Dufy would have known Monet's and Pissarro's forests of fluttering flags painted with a broken Impressionist touch. The little, shorthand figures scurrying in the spatial intervals between the flags in Dufy's painting reveal his debt to Impressionism, but by 1906 a new structure and boldness of design emerges in his work. In *July 14 at Le Havre*, the large, vividly coloured *tricolors* swing out high over the street, dominating the composition, and, with their strong vertical and horizontal lines, create a powerfully rhythmic, and even epic, composition.

AD

RAOUL DUFY
(1877–1953)
*The Boats at Les Martigues
(Les Barques à Martigues)*
1907

signed lower right *R. Dufy*
oil on canvas 54 × 65 cm
Private collection

The works Dufy painted in the south of France in the summer of 1907 display a new sense of structure and weight. The insistent flatness in the Le Havre flag paintings of the previous year (page 43) and the airy calligraphy we find in *Passers-by* (page 42) now give way to a new concern with solid form. In *The Boats at Martigues* the animation that Dufy's little figures usually bring to a scene has gone, and there is little sense of the local topography. It is the bold, imposing silhouettes of the empty boats with their rhythmic elliptical contours that have captured Dufy's interest and that dominate the foreground. The colours, too, are more resonant than the singing hues of Dufy's earlier Fauvist style. A rich palette of emerald greens, burnt oranges, blues and ochre-yellow, lightened here and there with pink, pale blue and white, are woven together in a dense, almost airless fabric of brushwork that fills the entire canvas.

Like many artists in Paris in 1907, Dufy was profoundly affected by the Cézanne retrospective at the Salon d'Automne. *The Boats at Martigues* displays the lessons Dufy learned from Cézanne, especially those of modelling forms with colour alone and filling the intervals between objects with a woven texture of parallel brushstrokes. Dufy would soon pursue these ideas in his own brand of Cubism. In his later work, Dufy returned to a decorative, calligraphic style, and also achieved considerable success with his textile designs.

AD

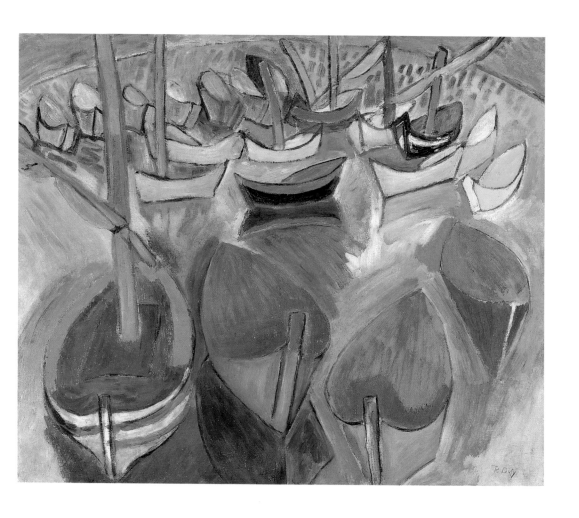

KEES VAN DONGEN
(1877–1968)
*The Violoncellist at the
Moulin de la Galette (Le
Violoncelliste au Moulin
de la Galette)* 1905

Signed lower right *van
Dongen 05* and titled
Violoncelliste on the verso
oil on canvas 65 × 53.5 cm
Fridart Foundation

From his first visit to Paris in 1897, the Parisian *demi-monde*, its cafés, dance halls and prostitutes, had enthralled the Dutch-born Van Dongen and inspired much of his early work. In 1903 he began frequenting the Moulin de la Galette, the windmill turned dance hall which since the 1870s had inspired many painters, including Renoir and Picasso. It is likely that he was allowed unlimited access to the famous establishment, as the owner, Auguste Debray, applied a free-entry policy for artists, believing (correctly) that drawings and paintings of the Moulin would only serve to increase its fame. Here Van Dongen represents the dance hall through only a handful of discernible objects: the neck of a 'cello, the corner of a music stand and a decorative vase of flowers, which seems precariously positioned on the edge of the orchestra's balcony. The bustle of the crowd and festive atmosphere of the dance hall at night, with its dazzling chandeliers like "glowing coloured suns", are rendered with a multitude of vibrantly coloured strokes, similar to those used by Seurat and Signac in their pointillist paintings. It is likely that this fragmentary image is part of a larger composition entitled *At La Galette (A la Galette)*, which Van Dongen exhibited in the Salon des Indépendants in 1906 and which he cut into pieces in the 1950s, selling the parts as independent works.
SF

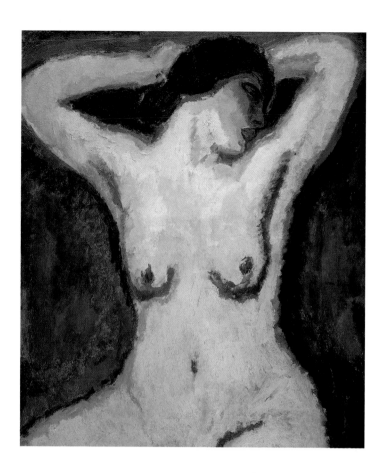

KEES VAN DONGEN
(1877–1968)
Torso (Torse); also known
as *The Idol (L'Idole)* 1905

Signed centre right
van Dongen
oil on canvas 92 × 81 cm
Fridart Foundation

Van Dongen's wife Guus was the model for this sensual nude; she is identified by her distinctive red lips outlined in black. She is represented in a moment of total abandon, her arms raised and her head turned. She exudes sensuality while at the same time remaining detached and independent. The luminous colours and bold brushstrokes of her flesh contrast with the dark background, while the reddish glow that surrounds her makes her look red hot, literally burning with passion. With this emphasis on sensuality Van Dongen was to define the Fauve nude and to create his own feminine ideal, which he applied to many of his female portraits of the period.

Van Dongen studied at the Academy in Rotterdam between 1892 and 1897, and there met Augusta Prettinger, 'Guus' He settled in Paris in 1899, and an exhibition of his work at Ambroise Vollard's gallery in 1904 signalled his entrance on the Parisian art scene. In 1905 this painting and another, also of Guus, were exhibited in the famous Salon d'Automne that included the notorious gallery of the '*fauves*'. Although he was never a member of the core group, his paintings share with the Fauves an emphasis on the expressive and autonomous qualities of colour, though his is still more arresting and strident. In 1908 he was invited to join the German Expressionist group *Die Brücke*.

SF

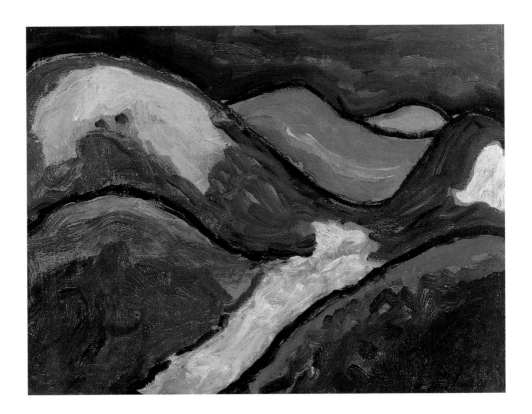

ALEXEI JAWLENSKY
(1864–1941)
*The Dunes of Prerow (Die
Dünen von Prerow)* 1911

Signed and dated lower right
A. Jawlensky 1911
oil on board mounted on
canvas 32.5 × 44.5 cm
Private collection

The darkly drawn contours that hold the intense masses of colour on
the surface plane have a flattening effect and deplete Jawlensky's land-
scape of any spatial dimension, making it almost abstract. This effect is
enhanced by the absence of human figures, which ensures that the image
is without narrative reference or anecdote. Instead it is endowed with
a symbolic and emotive connotation, which is achieved by the exagger-
ated undulating forms of the dunes, expressing the interpenetration
of the external world and the artist's passionate feelings.

Jawlensky spent the summer of 1911 at Prerow on the Baltic coast,
and it was there that he developed his mature personal style; later he
wrote: "I painted the best landscapes of my career to date while I was
there I used a great deal of red, blue, orange, cadmium yellow,
chrome-oxide green. The forms were very emphatically contoured in
Prussian blue and emerged irresistibly from an inner ecstasy." With
its use of stridently coloured pictorial elements enclosed in black
contours, this painting is representative of the works Jawlensky painted
when working alongside Kandinsky and Münter (see page 52) in the
Bavarian town of Murnau between 1908 and 1910. It also reflects
Matisse's paintings, which Jawlensky knew from as early as 1905, and
his desire to fuse the lessons learned from the French master with
those of the more spiritually inspired images of the Nabis. From the
Nabis Jawlensky derived the expressive effects of flat painting and the
concept of an all-embracing pictorial 'synthesis'.

SF

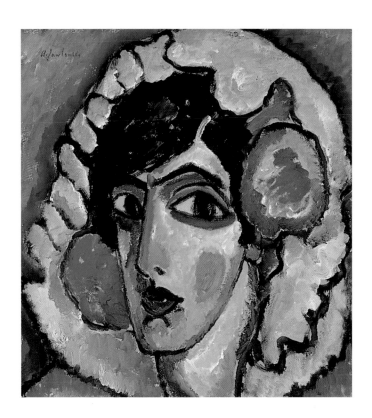

ALEXEI JAWLENSKY
(1864–1941)
Manola 1913

signed twice upper left
A. Jawlensky and dated on
the reverse
oil on board 54 × 50 cm
English private collection

Manola is one of the several powerful portrait heads that Jawlensky
began to paint from about 1910 onwards. With her jet-black hair,
elaborate headdress with bright pink flowers, her dark blue lips
contoured with a heavy black line, and her enormous eyes with their
dilated pupils and arched eyebrows, the woman in the image stares
at the viewer with melancholy introspection. Despite the Spanish-
sounding title of the painting, of a kind that Jawlensky was fond of
bestowing on his works of the period, the subject's sharp features and
long angular face turned slightly to the left recall a *Self-portrait* of 1908
(Städtische Galerie, Munich) painted by Marianne von Werefkin,
Jawlensky's long-term companion and supporter.

Werefkin and Jawlensky, who stayed together for some thirty years,
met in St Petersburg in 1901 when they were fellow students of the
Russian academic painter Ilya Repin. Seeking to escape the limitations
on expression enforced by the Russian art establishment, in 1896 they
moved to Munich to study in the more progressive studio of the artist
Anton Azbè. It was there that Jawlensky made the acquaintance of
another expatriate Russian artist, Wassily Kandinsky (see pages 53–58),
and that he began his lifelong mission of experimentation, seeking
through a combination of colour, line and form to express his inner-
most self.

SF

ALEXEI JAWLENSKY
(1864–1941)
Blue Cap (Blaue Kappe)
1912

Signed lower left *A. Jawlensky*
and lower right *A.J.*
oil on board 65 × 54 cm
Fridart Foundation

The *Blue Cap* is not a portrait in the conventional sense, although the young girl portrayed captivates the viewer with her enormous almond-shaped eyes. Instead, Jawlensky uses intense non-naturalistic colours to reveal her jovial character and inviting disposition. The repeated circular forms and radiating bands of colour serve to create a stylized likeness of a female figure, while the strident colouristic harmonies of reds and pinks, blues and greens, together with the black contour lines, flatten the image, making it seem highly decorative and conferring a sense of dynamism to an otherwise static portrayal. The forceful nature of the image gives it a monumental and ideographic quality that anticipates Jawlensky's later imaginary and abstracted faces.

In two extended stays in France in 1903 and 1905 (Brittany, Paris and Provence), Jawlensky had had a chance to study the work of Gauguin, and also the latest trends as represented by Henri Matisse and the Fauves. From then on he declared his desire to paint not what he saw but what he felt. Following a trip to the Baltic Sea, renewed contact with Matisse in 1911 and an encounter with Emil Nolde in 1912, Jawlensky concentrated increasingly on the expressive use of colour and form in their own right; he substituted for his interest in individual features and traits a desire to depict a more hidden and profound essence of reality. Although he was still painting still lifes and landscapes, Jawlensky's preferred theme from this time onwards was the portrait.

Gradually Jawlensky abandoned the half-length format of his portraits, replacing them initially with busts, such as *Manola* (see previous page), and then, after 1916, with the face in isolation. "A face for me is not a face, rather an entire world", he wrote later on in his life. Disquieting and atavistic, his images became increasingly mystical and spiritual, like modern-day icons. With his female portraits, Jawlensky recalls the formal imagery of the Virgin Mary in Byzantine art – maternal and sensual, sweet yet mysterious. These images, together with his later series of *Mystical Heads* of 1917–19 and his *Saviour's Faces* of 1918–20, link his work directly to the spiritual traditions of his Russian origins.
SF

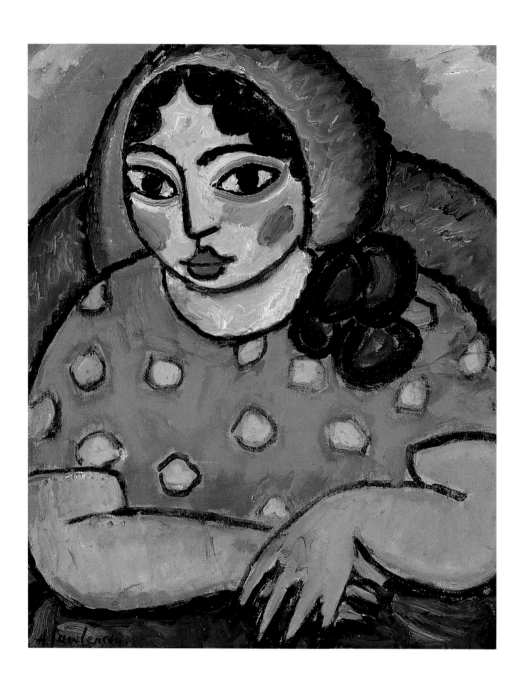

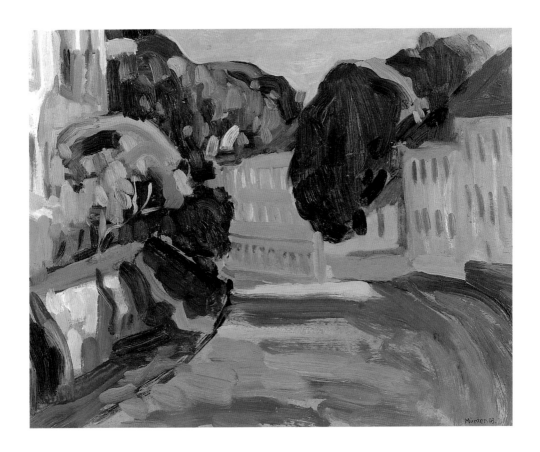

GABRIELE MÜNTER
(1877–1962)
*Street in Murnau
(Murnauer Strasse)* 1908

Signed lower right *Münter*
oil on board 33 × 41 cm
Private collection

Münter first visited Murnau, a small market town near Munich, with
her mentor and then partner, Wassily Kandinsky, during the summer of
1908. The picturesque and colourful town had recently been renovated
according to the traditions of Bavarian domestic architecture and
decoration. In Münter's *Street in Murnau* the façades of the houses are
depicted with flat planes of colours linearly arranged in a seemingly
perspectival construction and interspersed with areas of broad brush-
strokes, partially outlined in black, that suggest the trees and mountains
beyond. The roughly hewn brushwork of the street in the foreground
contrasts with the distant azure sky, which is rendered without a nuance
or cloud, as a simple, untextured surface. Like many of Münter's images
of Murnau, this street scene is devoid of villagers or visitors. Instead,
it is pervaded by a timeless stillness that encapsulates the essential
rural charm of small German villages.

The paintings Münter and Kandinsky produced in Murnau between
1908 and 1909, using bold, anti-naturalistic colour and a synthetic
approach to its symbolic and emotive power, were crucial for the
development of a modernist vocabulary of Expressionism in Germany.
Their radical approach to painting was influenced in part by the ideas
of Marianne von Werefkin and Alexei Jawlensky (see pages 48–51),
who worked closely with them in Murnau during these years.

SF

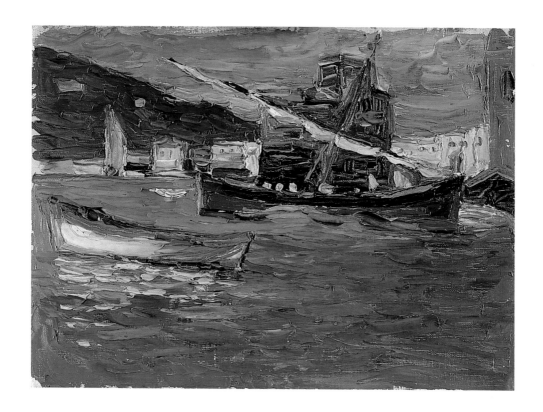

WASSILY KANDINSKY
(1866–1944)
Rapallo: Grey Day
(*Rapallo: Grauer Tag*)
1905

oil on canvas board
24 × 33 cm
Private collection

Following a year of travel through Tunisia, Germany and Italy, Kandinsky spent the winter of 1905–6 with his companion and former student Gabriele Münter (see opposite page) in Rapallo, east of Genoa. Here, Kandinsky painted views from the house they rented in via Montebello and also several depictions of the bay, such as this one. For practical purposes, while travelling he made use of small-scale canvas boards on which it was convenient to work in rented apartments or indeed *en plein air*. In this example, his portrayal of the town's harbour retains the freshness and spontaneity of an outdoor sketch, the paint having been applied in short strokes with a palette knife and, in some areas, squeezed directly from the tube. During this period Kandinsky painted a large number of oil sketches from nature, which show both an increasing awareness of the possibilities of non-descriptive colour and an interest in technical experimentation. The painterly features of the Rapallo canvases advance beyond his Tunisian landscapes, which still retain elements of 'coloured drawing' consistent with his earlier interest in the techniques of *Jugendstil* or Art Nouveau.
SB & BM

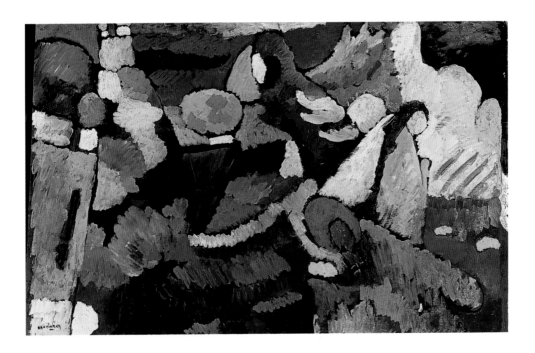

WASSILY KANDINSKY
(1866–1944)
*Improvisation on
Mahogany (Improvisation
auf Mahogoni)* 1910

signed lower left *Kandinsky*
oil on mahogany panel
63.5 × 100.5 cm
Fridart Foundation

By 1910, Kandinsky was working in three parallel modes, which he characterized as "Impressions, Improvisations and Compositions" in his major treatise of 1912, *On the Spiritual in Art*. The musical metaphor was deliberate, reflecting Romantic and Symbolist legacies of the interrelationship between the arts. Art should not be conditioned by observing the sensations of the outer world; it had its own intrinsic, spiritual nature, which involved an interplay between the various elements of line, colour and shape. Above all, the psychological and emotional impact of colour was deemed an effective means of reaching the soul of the viewer, comparable to the 'vibrations' of sound transmitted to a listener's ear. Clearly, the *Compositions* were the most intensively researched and abstract of his works. The *Improvisations* were described as resulting from a "largely unconscious, spontaneous expression of inner character". Yet in *Improvisation on Mahogany* we can decipher the overall imagery, notwithstanding the obscurity of the central area.

In general appearance, this *Improvisation* recalls elements of Kandinsky's Murnau landscapes (see page 52). Encouraged by Jawlensky's example (see pages 48 and 49), Kandinsky has given up the palette knife in favour of short-haired brushes and larger, unprimed boards. He has worked directly on a mahogany panel, at times revealing the wooden ground, so as to evoke the 'raw' appearance of painted folk art carvings. However, while the amphitheatre of the Bavarian setting is retained, the versatile brush technique and variegated facture undermine the solidity of the objects and figures. The spectator is drawn instead to exploring the surfaces and exotic colourism – a dominance of warm reds through to pink and ochre – that compellingly resist visual resolution.

SB

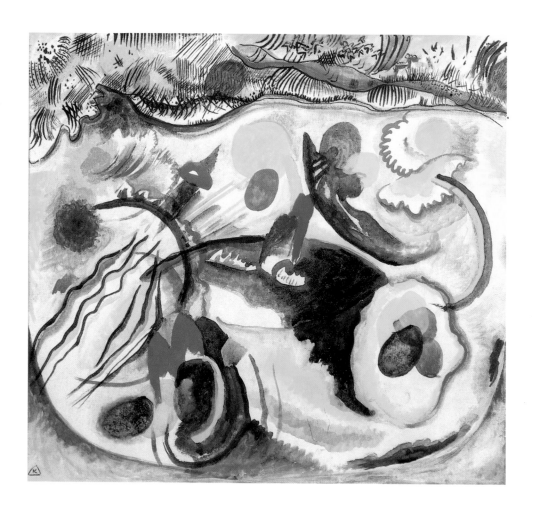

WASSILY KANDINSKY
(1866–1944)
On the Theme of the Last Judgment (Zum Thema Jüngstes Gericht) 1913

signed lower left with monogram
oil and mixed media
48 × 52 cm
Fridart Foundation

Between 1909 and 1913, Kandinsky painted seven major *Compositions*, to several of which he gave subtitles. As he revealed in his important 'Cologne Lecture' of 1914, "I calmly chose the Resurrection as the theme for *Composition 5*, and the Deluge for the sixth. One needs a certain daring if one is to take such outworn themes as the starting point for pure painting." While Kandinsky did not specify a theme for *Composition 7*, various motifs have been traced to the iconography of the Last Judgment.

This work probably served as one of many preparatory sketches for the final *Composition 7*. It is highly experimental. Kandinsky has reverted to his earlier exploration of mixed-media glazes – tempera, oil and watercolour – but now achieves an entirely different and translucent surface effect. Deluge-like organic contours demarcate this evocation of a cosmic landscape, and the artist introduces the unusual contrast of Indian-ink drawing in the top section of the canvas. Kandinsky's use of apocalyptic subject-matter derived not only from the challenge to reinvent "outworn themes", but also from his keen interest in the esoteric theories of the German Anthroposophist Rudolf Steiner.

SB

WASSILY KANDINSKY
(1866–1944)
In the Black Circle (Im schwarzen Kreis) 1923

signed and dated lower left
with monogram and 23
oil on canvas, 130 × 130 cm
Fridart Foundation

In 1914, with the outbreak of the First World War, all Russian citizens in Germany were declared aliens, and Kandinsky left in haste for Switzerland. He spent the next seven years in Moscow and, in the wake of the October Revolution, participated in the fervour of cultural and institutional reform. The official embrace of avant-garde art meant that Kandinsky was given the opportunity to engage in organizational and pedagogical activities. In 1920, he headed the Moscow Institute of Artistic Culture (Inkhuk) and his 'Programme', presented at the First Pan-Russian Conference of Teachers and Students, extended his theoretical enquiry into the function of line, shape and colour. However, Kandinsky's sustained belief in the expressive and mystical values of art led to the rejection of his programme. His increasing isolation within this Constructivist milieu no doubt contributed to his desire to return to Germany. Yet it is clear that his oeuvre was transformed by his exposure to the Russian avant-garde, for he abandoned the Expressionist abstraction of the Munich years and explored geometric formal elements in a more systematic manner. Given this background, it is understandable why Kandinsky was approached to teach at the Bauhaus in Weimar. Founded in 1919 by the architect Walter Gropius, this school was based on socialist and Utopian principles that placed artists at the centre of a new kind of design that would serve modern society.

The painting *In the Black Circle* is a major work that Kandinsky completed in January 1923, six months after his arrival at the Bauhaus. It consolidates the freer forms found in his pre-war works and at the same time the Constructivist influence, which is perhaps most apparent in his appropriation of the circle against the square white canvas. In 1930, Kandinsky commented in a letter to his biographer Will Grohmann that he found that the circle was a link to the cosmic and was "a precise but inexhaustible variable . . . that carries countless tensions within it". The picture balances the force of the black pressing out into the white space with the centripetal movement that draws the 'non-objective' objects into the centre. Primary colours are spliced together between flattened intersecting planes and juxtaposed with dappled areas and referentially void ovals and dots. Contained within an endless shape, the graphic and the painterly elements compete and bare their inconsistencies with one another while remaining subordinate to the dominant circular form. Contributing to the Theory of Form classes as well as to the Wall Painting workshops, Kandinsky's scientific analysis of art led to the publication of his treatise *Point and Line to Plane* in 1926. However, the relationships within this simultaneously stable and unstable painting move vigorously beyond the didactics encountered in this theoretical text.

SB & BM

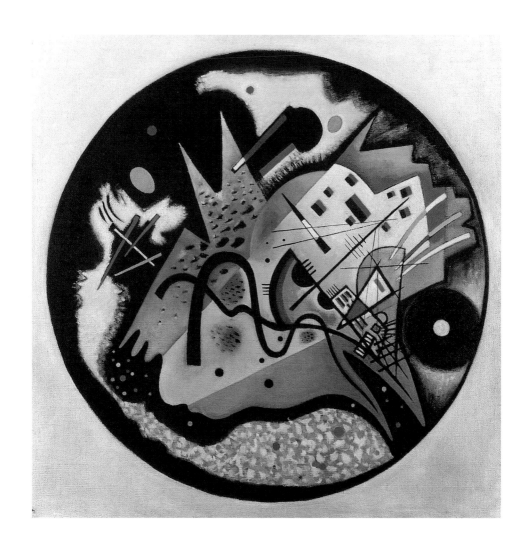

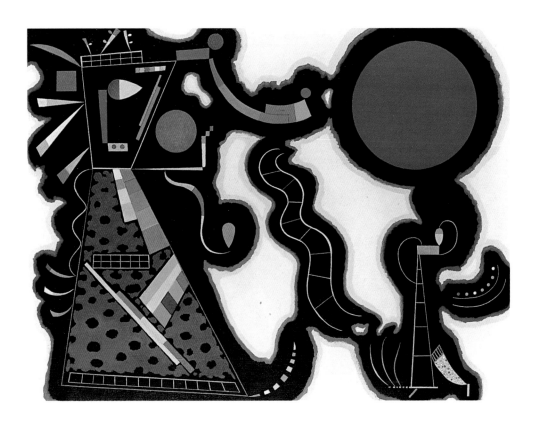

WASSILY KANDINSKY
(1866–1944)
*The Red Circle (Le Rond
rouge)* 1939

signed and dated lower
left *K.39*
oil on canvas 89 × 116 cm
Private collection

Already in mid 1932, the right-wing majority in the Dessau city
legislature, which was led by the Nazis, voted for the dissolution of
the Bauhaus. Kandinsky moved with the school to Berlin, but the
Bauhaus was finally closed after the Nazi accession to power in April
1933. Kandinsky found it impossible to exhibit or find employment,
and he left for Paris, where, by early 1934, he and his wife Nina were
installed in a new apartment at Neuilly-sur-Seine. His assimilation
into the Parisian milieu was not sudden, however, for his works had
already been exhibited in the *Cercle et Carré* group show in 1930
and in the Surrealist exhibition of the *Salon des Surindépendants* in
1933. Painted in the year that Kandinsky acquired French citizenship,
this work shows the characteristics of the Paris period. Biomorphic
shapes provide an irregular organic ground for the playful geometric
construction on the left, the ladder elements on the right and saturated
red of the circle. This work certainly suggests comparison with those
of Arp and Miró, notwithstanding Kandinsky's vehement rejection of
such analogies.

SB

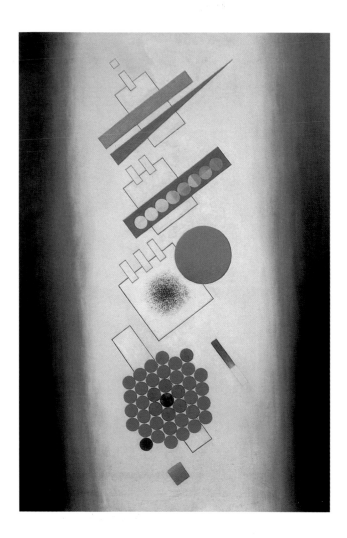

RUDOLF BAUER
(1889–1953)
Delicacies 1935

signed lower right *R. Bauer*
oil on canvas
135.2 × 89.5 cm
Fridart Foundation

Geometric forms in reds, mauves, orange, green and black ascend the canvas. The overlaid forms, arranged in a tonally subtle composition, recall the cosmic paintings of Kandinsky of the early 1920s, which Bauer admired greatly. Bauer, who started his career as a caricaturist, had begun to incorporate Kandinsky's ideas and stylistic innovations into his own work in 1915, when both artists exhibited in Berlin at the Glaspalast and in Herwarth Walden's avant-garde gallery Der Sturm.

During the 1920s Bauer conceived of a museum for non-objective painting and in 1929 he opened '*Das Geistreich*' (The Spiritual Realm) in Berlin, where he showed his own work alongside that of Kandinsky. Hilla Rebay, his lover and advocate for many years, collected his work on behalf of Solomon R. Guggenheim, whose visit to Bauer's museum reinforced his own passion for non-objective art. Branded as a 'degenerate' artist by the Nazis in 1939, Bauer was forced to flee to the United States. After his break-up with Rebay, Bauer spent the last years of his life in relative obscurity.

SF

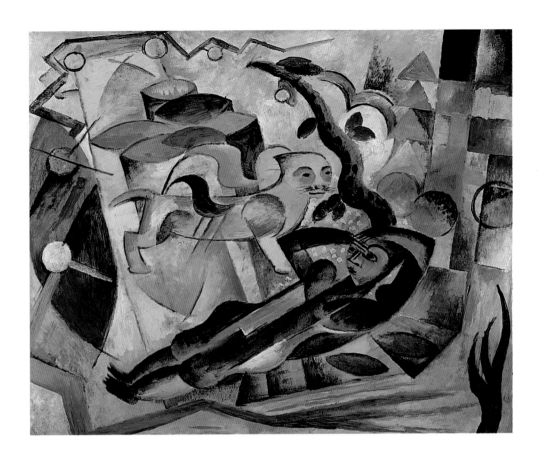

HEINRICH
CAMPENDONK
(1889–1957)
The Dream (Der Traum)
ca. 1913

oil on board 60.5 × 75 cm
Private collection

A reclining female figure and a winged animal float in a dream-like fantasy; they are swathed in a magical landscape of stylized trees, zig-zag lines and a myriad of coloured geometric shapes. The imaginary scene evokes the harmony between man and beast at the time of the Creation. In early works such as this, Campendonk used harmonious and often transparent applications of sumptuous blues, greens, oranges and yellows to create his mystical images, reflecting his fascination with the cycle of life, of becoming and passing. The distinctly patterned quality of the painting may derive from Campendonk's early training as a textile designer at the Arts and Crafts school of Krefeld under the Dutch painter Johan Thorn Prikker. In 1911 he was invited by Franz Marc and Kandinsky (see page 54) to Sindelsdorf in Upper Bavaria, and in the same year his painting *Leaping Horse*, indebted to the compositional style of Marc, was included in the first exhibition of the *Blaue Reiter* artists, in Munich. Campendonk's paintings of this period also betray the influence of the decorative colourism of Macke (see page 64) and his admiration for Robert and Sonia Delaunay's Orphist paintings, together with a taste for Bavarian folk art. During the First World War Campendonk destroyed many of his earlier works. *The Dream* is one of the few to survive from his *Blaue Reiter* period.

SF

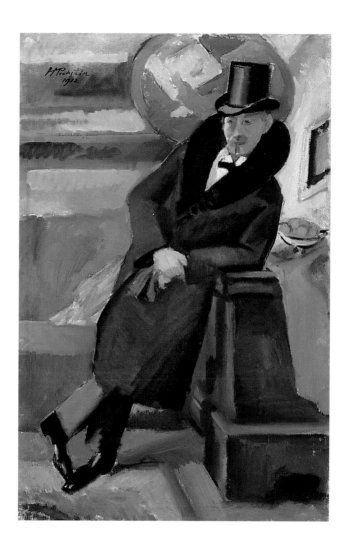

MAX PECHSTEIN
(1881–1955)
Portrait of a Man
(Männerbildnis)
ca. 1912–13

signed upper left
M Pechstein 1912
oil on canvas 60 × 40 cm
Private collection

The style of this genial if unconventional portrait of an unidentified man, with its muted tones and touches of bright colours, is less strident than much of Pechstein's art of the period. From 1906 he had been closely involved with *Die Brücke*, sharing with the group a desire to create a new style of painting that would be in tune with modern life. However, Pechstein, unlike the founders, Heckel, Kirchner and Schmidt-Rottluff, who were all architecture students, had received a formal academic training as a painter, and, as this portrait demonstrates, his pictorial style was to remain essentially conservative. Unable or uninterested in liberating colour from its descriptive function, he maintained a more naturalistic form of representation than the other *Brücke* artists. At the time he painted this portrait, however, Pechstein was a rising star, his more accessible style making him the most popular of the new generation of Expressionists.
SF

MAX PECHSTEIN
*Women at the Sea (Frauen
am Meer)* 1919

signed and dated lower left
M P 1919
oil on canvas 120 × 90 cm
Fridart Foundation

Although they cannot be identified, either as individuals or as specific racial types, the angular and simplified features of the three women represented in this beach scene call to mind the stylized forms of African and Oceanic sculpture. Their dark skin-tones outlined with bold black lines are set against a background of intense areas of yellows, purples and blues, which animate the beach and sea beyond and recall the vigorous colours of earlier Expressionist paintings by the artist.

On the right, patches of paler yellows float along the water, depicting the flickering reflections of the setting sun in a Munch-like fashion, while on the far left a small half moon is clearly visible. A seemingly self-conscious seated figure in the foreground is being shielded or covered by a cloth held by another figure, wearing a head scarf, while a third figure exiting from the water in the background looks on. A sentimental exoticism pervades Pechstein's image of these female 'natives', although it is unclear where the enigmatic scene actually takes place.

Like the other artists of *Die Brücke*, with whom he associated before the First World War, Pechstein had a profound interest in the idea of the primitive. It was his desire to follow in the footsteps of Gauguin to Tahiti that prompted his visit to the Palau Islands in the South Seas in 1914. Much like his illustrious predecessor, Pechstein understood the islands in terms of his own romantic expectations. In Palau he found the integration of nature and mankind that he had sought when painting naked bathers with Heckel and Kirchner at the Moritzburger lakes near Dresden, during a few weeks in the summer of 1910, and in Nidden, a fishing village on the Baltic Sea where he spent every summer from 1909 onwards.

With the outbreak of war and a difficult return journey to Germany in 1915, nearly all the works he had made in Palau were lost; even so, the assimilation of his Pacific experiences preoccupied Pechstein for a long time, and after the war he set about 'remaking' his South Seas paintings. In his *Palau Triptych* of 1917, with its eclectic mixture of African and Oceanic references, Pechstein overcame the distance between experience and memory to create an idealized image of organic unity between art and society.

In aspiring to a closer relationship between man and nature, Pechstein connected his own working-class origins with the 'primitive' lifestyles he encountered, whether in the South Seas or in his native Germany. His concerns about post-war German society led him to become one of the founding members of the Novembergruppe, a group of radical left-wing artists who aimed to foster a closer relationship between progressive artists and the public in order to aid social renewal.
SF

AUGUST MACKE
(1887–1914)
*Three Girls with a Dog in
front of a Garden Gate
(Drei Mädchen mit Hund
vor Gastentor)* 1913

oil on canvas 80 × 60 cm
Fridart Foundation

The light-hearted mood of Macke's *Three Girls with a Dog* is typical of several works he painted in 1913 and 1914, evoking a world of modern paradises such as parks, zoos or waterside promenades. Three young girls chat in front of a gated wall; behind it we glimpse a lush garden of trees and a tower. In the *Blaue Reiter* circle Macke was the only artist to paint modern-life subjects. His gentle colourist harmonies differ from the jarring juxtapositions usually found in Expressionist painting and reflect the influence of the simultaneous colour contrasts of Delaunay's works, which Macke saw on a visit to Paris in October 1912. Inspired by Delaunay's shimmering colours and the tenets of Cubism, Macke had begun to distance himself from the *Blaue Reiter* artists' pre-occupation with the symbolical-mystical and non-objective, reverting instead to representing impressions of the visual world. He was killed in the First World War. After his death Marc wrote, "More than any of us he gave colour the clearest and purest sound – as clear and lucid as his whole being".

SF

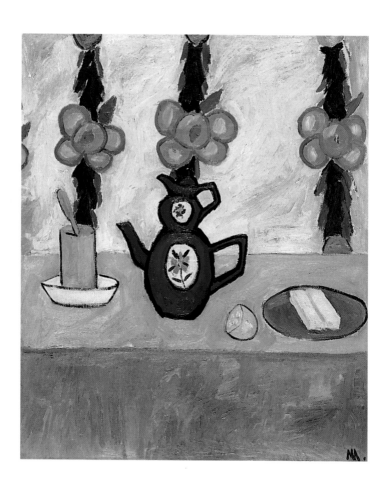

MIKHAIL LARIONOV
(1881–1964)
*Still Life in a Major Scale
(Nature morte en gamme
majeur)* 1907

signed lower right in
Cyrillic initials
oil on canvas 97.7 × 77 cm
Fridart Foundation

Larianov's admiration for Cézanne's still lifes is apparent in this stylized image, with its flattened forms, lack of recession and perspectival distortions. The still-life objects – a Russian teapot, half a lemon, a honey pot and a plate with biscuits or cake – are placed randomly on the table in front of richly patterned floral wallpaper. Larionov's simplified shapes and naïve imagery are derived from indigenous Russian arts such as *lubok* (peasant woodcuts), embroidery and toys, while the assertive brushstrokes and unusually strident colours recall the Fauve paintings that Larionov would have seen in Paris in 1906, when, at the invitation of Serge Diaghilev, he was invited to participate in the Russian art exhibition at the Salon d'Automne. A tireless and dynamic organizer, in 1908 Larionov would be the inspiration behind the Franco-Russian exhibition *The Golden Fleece*, held in Moscow, which introduced French Post-Impressionist, Fauve and pre-Cubist works to the Russian public. In the 1909 edition of the exhibition, Larionov and Natalia Goncharova, his lifelong friend and companion, launched their work under the banner 'Neo-primitivism', developing their blend of Russian folk art with Fauvist boldness of line and abstract use of colour. The pendant to this painting, *Still Life in a Minor Scale*, of 1907 (with Acquavella Galleries, New York, in 1969) contains similar still-life objects.
SF

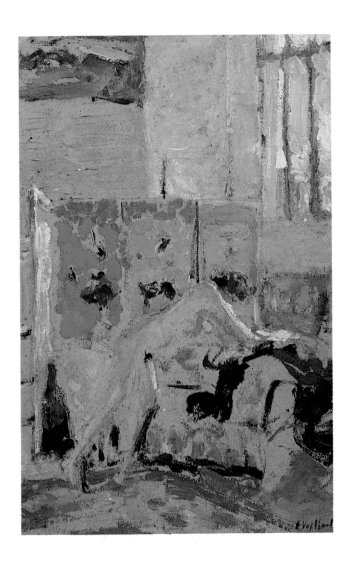

EDOUARD VUILLARD
(1868–1940)
*Interior: The Screen
(Intérieur: Le Paravent)*
ca. 1909–10

signed bottom right *E Vuillard*
oil (*peinture à l'essence*) on
paper, laid down on panel
35.8 × 23.8 cm
Courtauld Bequest, 1948

A nude model is seen in an artist's studio, seemingly caught between poses as she reaches for her clothes. The theme of an artist's model depicted off guard was common in Salon painting in France, and the *frisson* of such paintings was overtly voyeuristic. The viewer was offered a glimpse of the naked model at a moment when her nakedness was not legitimized by a formal artistic pose that would make her a 'nude'. Here Vuillard undercuts the associations of the subject by the way in which the figure is treated. The image is handled very summarily, and the figure in particular is little worked. The woman's body is almost evoked in negative, which defuses its eroticism. The richest colours occur in the screen, but overall the colour is quite muted, with true black used for the drapery on the sofa and, in a tiny dab, to suggest the model's pubic hair. The surface of the painting is very matt, and has never been varnished – leaving it in the state that Vuillard would have wished.

JH

66

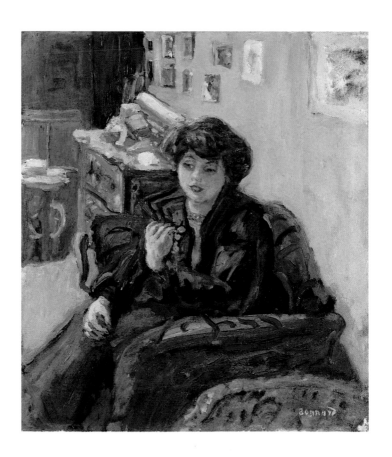

PIERRE BONNARD
(1867–1947)
*Young Woman in an
Interior* 1906

signed lower right *Bonnard*
oil on canvas 48.9 × 44.5 cm
Gift of the Roger Fry Trustees,
1935

The sitter is the artist's mistress and future wife Marthe Boursin.
From the time he first painted her in 1894 she was his most frequent
model. Among Bonnard's most striking images are the many paintings
of her in the nude, at her toilette or in the bathroom. In this deceptively
simple informal 'snapshot', the darkly clad Marthe is caught in a
moment of suspended animation, holding a bunch of grapes before
her half-open mouth. Her silhouette fills the foreground but, through
the play of light, attention is focused as much on the room beyond.

From early in his career, Bonnard painted in the studio, not from
direct observation but from recollections of visual experiences. The
fleeting moment was frequently recorded in quick studies drawn on
the spot; he also practised photography, often with Marthe as his
subject. He had much in common with his friend Vuillard, whose
near-contemporary painting *Interior with a Screen* (opposite page)
shares some of this picture's intimate qualities. The term '*Intimiste*'
applies particularly to these two masters of the domestic interior.
HB

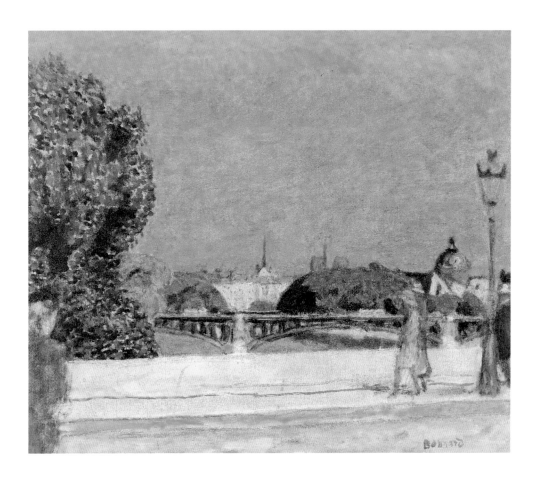

PIERRE BONNARD
(1867–1947)
*The Seine in Paris: The
Pont du Carrousel
(La Seine à Paris: Le Pont
du Carrousel)* 1922

signed lower right *Bonnard*
oil on canvas 47 × 57 cm
Private collection

Bonnard's picture explores one of the most celebrated views in Paris, from the Pont Royal up the Seine towards the Ile de la Cité, with the silhouettes of the Sainte-Chapelle and, to its right, Notre-Dame seen on the horizon, and, on the right, the dome of the chapel of the Institut de France. Yet his treatment of the view is unconventional. We catch no sight of the river itself, but only the bridges crossing it, the Pont du Carrousel and, above it, a hint of the Pont des Arts; and the foreground is taken up with a broad horizontal slab of roadway, peopled by a few casually grouped figures. It is as if we, like the figure cut off at the left margin, are about to cross the road to enjoy the view, rather than being face to face with the view itself.

Its technique is very varied; assertive dabs of paint on the tree on the left are contrasted with simpler, smoother surfaces elsewhere in the picture. The effect is one of afternoon sunlight, but the colour scheme is simplified and schematized, with rich blues and mauves in the sky set off against the pale yellows that dominate the foreground.
JH

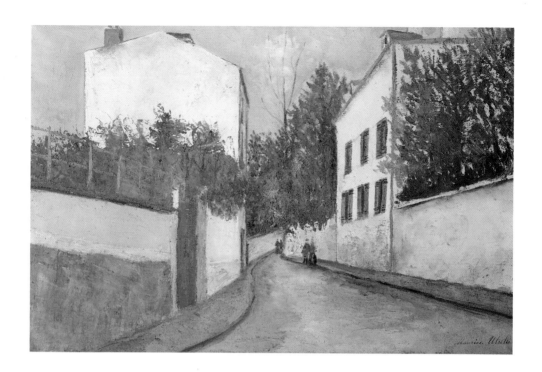

MAURICE UTRILLO
(1883–1955)
*Road at Sannois (Rue à
Sannois) ca.* 1912

signed lower right
Maurice Utrillo
oil on canvas 55 × 82 cm
Courtauld Gift, 1932

Utrillo, alcoholic son of the painter Suzanne Valadon, became the
stuff of Montmartre legends between the wars; his lifestyle and the
approachable imagery of his paintings satisfied the demands of artistic
bohemianism without challenging viewers aesthetically. Most of his
imagery was touristic – paintings of celebrated Montmartre scenes,
often based on picture postcards. *Road at Sannois* shows a lesser-
known site in a village near Argenteuil, ten miles outside Paris. Not
a particularly picturesque scene, it is presented with great immediacy,
with the walls as simple slabs of paint, set off by the rough textures
of the foliage. The chalky surface of the painting, happily unvarnished,
evokes the materiality of the walls it depicts. In conventional terms the
perspective is clearly faulty, but are such criteria appropriate for judging
the picture? Its simple forms suggest comparisons with the *naïveté* of
Henri Rousseau, himself unable to handle linear perspective; and
the frontality of the planes might suggest a relationship to the more
complex explorations of space and surface in the early Cubism of
Picasso and Braque. However, Utrillo's unconcern with nuances of
form and space suggests such comparisons are largely inappropriate.
JH

FERNAND LÉGER
(1881–1955)
*Contrasts of Forms
(Contrastes de formes)*;
also known as *Variations
of Forms (Variations de
Formes)* 1913
signed and dated *F. Léger 13*
on the reverse
oil on burlap 45.5 × 61 cm
Fridart Foundation

This work is one of the series of ground-breaking paintings, entitled *Contrasts of Forms,* that Léger made between 1913 and 1914. The title of the series misleads in that it refers only to the forms, whereas Léger himself referred to these paintings as "contrasts between forms and colours", and they are composed of forms, colour and light. The forms, although this painting is entirely abstract, are derived from Léger's earlier images of rooftops, billowing smoke and figures. These objective elements have been reduced to unidentifiable quasi-geometric symbols, outlined in black and highlighted with white, green, red, yellow and blue, which crowd the picture surface in a discordant arrangement. Any allusion to narrative has been removed, the colours no longer correspond to any naturalism, and the three dimensions have become confused; the stacked, drum-like polychrome forms float in a seemingly two-dimensional space. Léger described this imagery as "a search for multiple effects of intensity", his ideas recalling those behind the *papiers collés* of Picasso and Braque and Delaunay's notions of simultaneity. Léger's form of abstraction pushes to an extreme Cézanne's dictum to represent reality with "the sphere, the cube and the cone".

The physicality of the painting, consisting of raw patches of pure colour applied speedily on roughly woven burlap instead of canvas, intensifies its radical non-descriptive quality. The contrasting sequence of forms that move rhythmically across the picture plane create a dynamism that has analogies with Italian Futurism; yet Léger's painting differs in that it is devoid of the apocalyptic nuances implicit within Futurist imagery.

Léger's short-lived venture into the realm of pure abstraction, in which dynamic contrasts of form, line and colour supplanted representations of the visual world, was brought to an abrupt conclusion with the outbreak of the First World War and the artist's mobilization. Throughout his career, Léger strove to find a means of expression consonant with his times; these kaleidoscopic images of 1913 and 1914 had marked the moment in which he became a painter of 'modernity'. For him the dynamic dissonance of form, line and colour was the definition of, indeed the direct result of, rupture and change in the modern world. In 1913 he wrote, "Present-day life, more fragmented and faster-moving than life in the previous eras, has had to accept as its means of expression an art of dynamic divisionism". Unlike his contemporaries Mondrian, Kupka and Kandinsky, Léger was ultimately too enthralled by the modern world that surrounded him to opt for true abstraction. His only other brief foray into non-objectivity came in the mid 1920s, when he painted a series of abstract murals.

SF

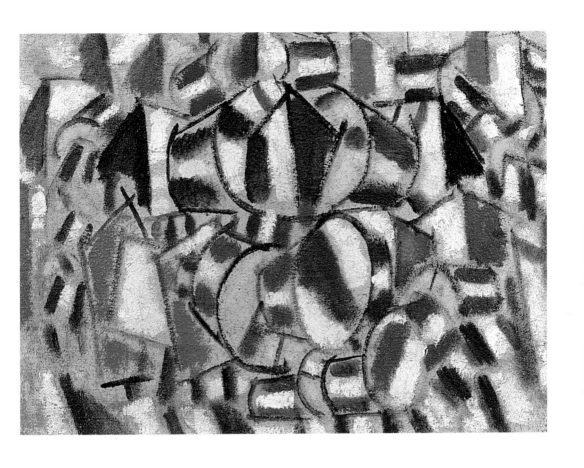

AMEDEO MODIGLIANI
(1884–1920)
Nude (Nu) *ca.* 1916

signed top left *Modigliani*
oil on canvas 92.4 × 59.8 cm
Courtauld Gift, 1932

In his nudes, Modigliani often chose poses that related to the main traditions of Western figure painting (to Manet, Ingres and earlier artists), but drew and painted them with a radical simplification that challenged the whole European figurative tradition. In *Nude*, the face is elongated, its features boldly simplified, in ways which testify to Modigliani's knowledge of Egyptian, African and Oceanic sculpture, though in a generalized way. Still the angle of the model's head recalls the very familiar imagery of the sleeping model, a favourite theme in the most conventional painting of the period. Likewise the contours and modelling of the body are treated in simplified, schematic arabesques, but elements such as the breasts and especially the pubic hair are described far more attentively.

Modigliani's brushwork was highly individual: characteristic scallop-shaped strokes can be seen in the X-radiograph of the painting, the paint being applied with a short stabbing action. The paint has been manipulated while still wet, ploughed through with a stiff brush in the background left and around the outline of the head, and scratched into with the end of the brush in the hair.

When a group of Modigliani's nudes were put on show at Berthe Weill's gallery in Paris in December 1917, the police first ordered the removal of the painting in the gallery window and then the closure of the whole exhibition. Apparently the prime cause of outrage was his explicit rendering of pubic hair, a taboo in the otherwise often very naturalistic depictions of the nude which hung every year without arousing any protest at the Paris Salon.

This painting, with its combination of traditional and avant-garde elements, was one of the very few paintings in Samuel Courtauld's collection by a member of one of the avant-garde groups that emerged after 1900; Cubism and even Fauvism were outside the parameters of his taste.

JH

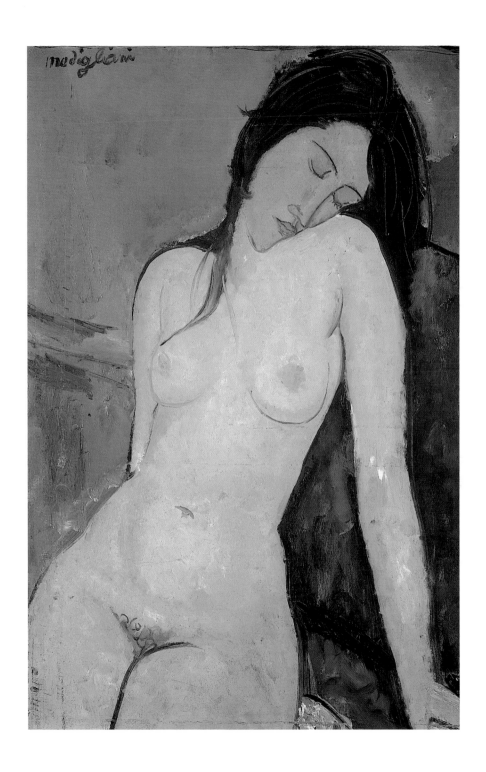

ALEXANDER
ARCHIPENKO
(1887–1964)
Walking Woman (Femme marchant), ca. 1912,
cast in 1954

signed lower left
bronze, height 67.3 cm
cast of an edition of 8
Fridart Foundation

In *Walking Woman* the suggestion of movement is conveyed through the slanted planes and forceful rhythms of the curvilinear volumes. The head and the torso are pierced by a hole, the hollowed-out shapes or perforations serving as a counterpoint to the surrounding masses. Archipenko was one of the first sculptors to recognize the aesthetic value of the void, using it as a substitute for mass in the composition. This important feature was to appear in the work of several later artists, among them Henry Moore and Barbara Hepworth (see pages 88, 89).

Alongside the influence of Cubist collage in Archipenko's sculptures, whereby he would employ polychrome elements of wood, metal and glass in the same work, as in *Medrano II* (1913; Solomon R. Guggenheim Museum, New York), *Walking Woman* displays a lesson learnt from Cubist painting – the optical ambiguity achieved by pairing concave and convex forms. In Cubist painting solid and void are of equal value and can interpenetrate and even substitute for each other. In this bronze piece, the highly stylized figure is constructed using interlocking concave and convex forms against a quasi-geometric flat support.

After having studied in the art schools of his native Kiev from 1902 to 1905, and been expelled for criticizing the academic attitude of his tutors, Archipenko arrived in Paris in 1908. In the French capital he entered the École des Beaux-Arts, but soon left, being impatient of discipline and preferring to familiarize himself with the art of the past by visiting museums such as the Louvre. By 1910 he had begun to associate with the circle of Cubist artists, exhibiting alongside them at the Salon des Indépendants and later at the Salon d'Automne. This sculpture brings together many of the Cubist-inspired forms Archipenko employed and developed for a decade or so from 1912 onwards.

After moving to the States in 1924 and taking up United States citizenship in 1928, Archipenko would somewhat haughtily deny his debt to Cubism, writing, "as for my own work, the geometric character of three-dimensional sculptures is due to the extreme simplification of form and not to Cubist dogma. I did not take from Cubism, but added to it." Significant and individualistic as his personal sculptural idiom was, this aspect of his multi-faceted output is nonetheless consistent with trends in the work of other sculptors of the period, such as Lipchitz and Duchamp-Villon.

SF

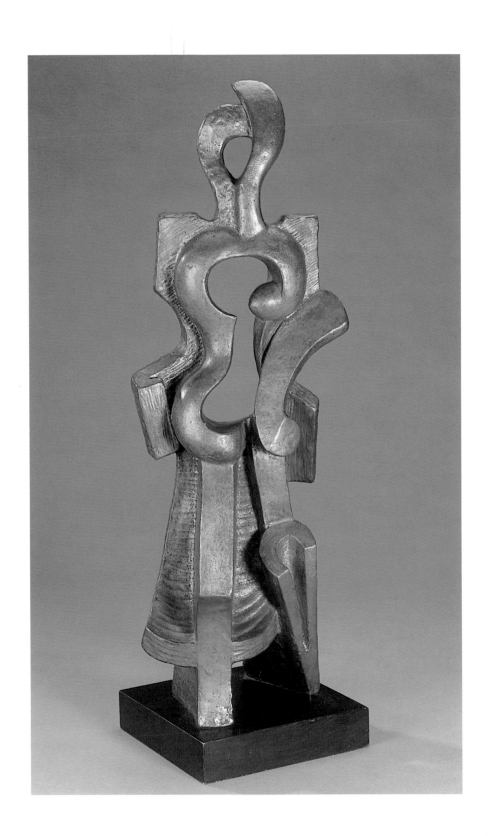

ROBERT DELAUNAY
(1885–1941)
The Runners (Les Coureurs)
1924–25

signed lower right
R. Delaunay Les Coureurs
1924–25
oil on canvas 153 × 203 cm
Fridart Foundation

Images of popular sports are relatively rare in early twentieth-century art. Delaunay undoubtedly knew Henri Rousseau's famous image of football players, *Les Joueurs de football* (1908; Solomon R. Guggenheim Museum, New York), which was shown at the Salon des Indépendants of that year, but it was his desire to represent the dynamism of modern life that led him to depict his own famous sporting images.

Already apparent in his *Cardiff Team* (*L'Equipe de Cardiff*; 1912–13; Stedelijk van Abbe Museum, Eindhoven) and in his projects for the spectacle *Football* that he designed with Léonide Massine in 1918, the theme of sport was to reappear in Delaunay's work in 1924, in a series of paintings and drawings entitled *The Runners*. This painting is one of several oil versions, of which only one shows the athletes running to the right of the image; the variations among the drawings are more extreme – some are surprisingly naturalistic, while others are almost entirely abstract: in these the faces of the runners are represented by circles, and schematic horizontal lines are used to depict their shirts. In this oil version Delaunay uses vertical bands of colours and a rhythm of forms across the canvas to indicate the powerful strides of the competitors and their relative positions in the race. The featureless oval shapes denoting their faces emphasize their anonymity but equally imbue them with an idealized quality. Delaunay employs a form of Synthetic Cubism to depict the movement of the runners in full flight, juxtaposing subtly contrasting coloured planes and lines.

Delaunay devoted much of his career to experimenting with the abstract qualities of 'pure' colour. He challenged the intrinsically static character of painting by exploring the interconnections between colour and movement and the relationships and emotions that resulted from the placement of one block of colour next to another. Before the First World War he had developed a form of completely abstract painting, known as Orphism, which was characterized by concentric circles of intensely vibrant and fragmented colours. The series of *The Runners* is one of the rare examples in Delaunay's work where movement is not suggested by the use of circular shapes.

In the post-war period, competitive sport encapsulated the cult of youth and the game. The bunched position of the athletes along the inside lane of the track suggests that they are taking part in a middle- or long-distance race. Such races became particularly popular in France after a French competitor won a gold medal in the first Olympic Games held after the war, in Antwerp in 1920. Undoubtedly Delaunay's interest in these races would have been even stronger in 1924, when the Olympic Games took place in Paris itself.

SF

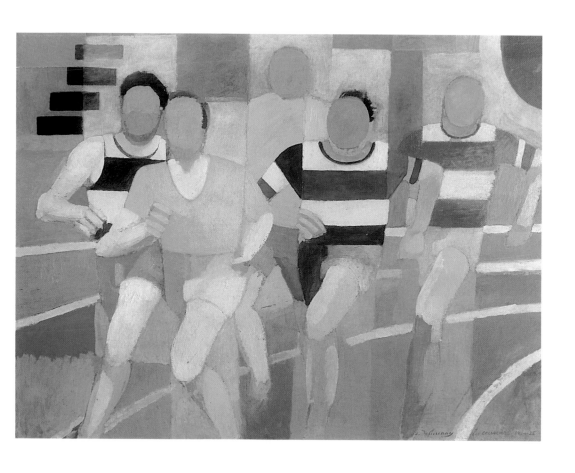

JEAN HIPPOLYTE
MARCHAND (1883–1941)
Saint-Paul 1921

signed lower right
J. Marchand
oil on canvas 61.5 × 74.5 cm
Courtauld Gift, 1932

Saint-Paul was one of the first canvases bought by Samuel Courtauld, acquired in September 1922. After the First World War, Cézanne and the late work of Renoir were regarded as prime examples for young artists; Marchand was one of the most influential young Cézannists. The subject and structure of *Saint-Paul* echo Cézanne's views of Gardanne of the mid 1880s. But, in place of Cézanne's modulated colour and complex relationships of line and plane, Marchand adopted a simpler palette and crisp modelling for the forms of the buildings. The Impressionist legacy in Cézanne's work is abandoned, in favour of a notion of Cézanne as a classicist, a creator of simplified, monumental compositions. The light of the Mediterranean coast is translated into clean, clear contrasts rather than vibrant colour.

In the simplified forms of buildings and clouds in *Saint-Paul*, there are also echoes of earlier prototypes – the backgrounds of fifteenth-century Florentine paintings such as those of Fra Angelico. The combination of this example with that of Cézanne marks a return to aesthetic basics, in reaction against both the atmospheric, colouristic concerns of Impressionism and the complexities of pre-war Cubism.
JH

HENRI LEBASQUE
(1865–1937)
*Young Girl at the Window
opposite the Ile de Yeu
(Jeune Fille à la fenêtre en
face de l'Ile de Yeu)*
ca. 1920

signed lower left *Lebasque*
oil on canvas 55 × 46 cm
Private collection

The subject is probably the artist's daughter Nono, who gazes reflectively across the harbour of Fromentine, near the mouth of the Loire, towards the Ile de Yeu, some 25 kilometres out to sea. A vase of flowers on the window sill links the interior and outdoor spaces. A woman seated in a window opening on to a landscape was a favourite theme of Lebasque and one that recurs in the work of Marquet (see page 35) and also in Matisse's Nice paintings of the 1920s.

Lebasque was a friend of Matisse and around 1905 had absorbed something of his brilliant innovations with colour and audacious handling of paint, but he never worked in a true Fauvist manner. His light colours and fluid paint are far more indebted to the Impressionists, notably Renoir. In this portrait, the shimmering muslin curtain to the left establishes a colour scheme of soft pinks, blues, whites and greys that fade into the pearly light of the water and sky. The sudden, sharp orange of the model's blouse provides a foil for the paler tones.

AD

MATTHEW SMITH
(1879–1959)
Lilies in a Jar ca. 1913

signed lower right *MS*
oil on canvas 61 × 55.9 cm
Lillian Browse Gift, 1982

Having spent an unhappy period training at the Manchester School
of Art and the Slade School in London, Matthew Smith travelled to
Pont-Aven in Brittany in September 1908. He would later mark this
as the beginning of his true development as a painter. In 1910 he
moved to Paris and joined Matisse's academy just before it closed. His
contact with Matisse was superficial but he experienced France and
contemporary French art as a liberation. This outstanding early work
was probably painted in Grez-sur-Loing, which Smith had discovered
on his honeymoon following his marriage to the painter Gwen Salmon.
The use of bright colours, the flatness of the design and the broad
areas of unpainted canvas illustrate his awareness of Fauvism and
his debt to Matisse.

Lilies in a Jar was given to the Courtauld Institute Gallery by Lillian
Browse as part of the distinguished collection of late nineteenth- and
early twentieth-century painting and sculpture which she formed as
an influential dealer and noted connoisseur and author.

EV

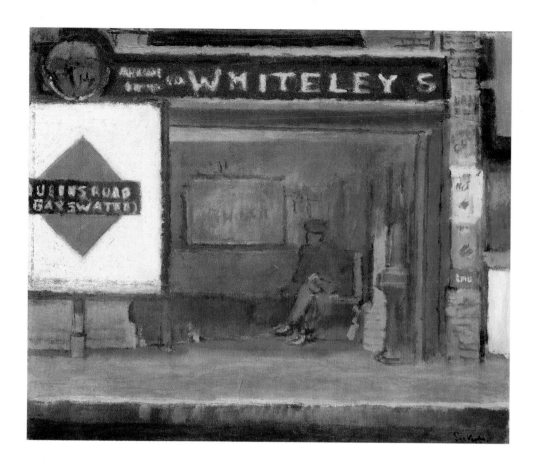

WALTER SICKERT
(1860–1942)
*Queen's Road Station,
Bayswater ca.* 1916

signed lower right *Sickert*
oil on canvas 62.3 × 73 cm
Gift of the Roger Fry Trustees,
1935

Queen's Road, now known as Bayswater Station, was one of the first underground stations in London. This painting shows a view across the tracks to a platform where a man is seated in a recess. Above is written *Alight here for Whiteleys*, referring to the famous department store nearby in Queensway.

At the time this was the nearest underground station to Sickert's home off Westbourne Grove, for him a familiar scene. The prominent rôle of the lettering – a common feature on the streets of London which furnished Sickert's subjects – is not unusual in his work. The painting's modernity is exceptional for this date, however. Its unpretentious contemporary subject and its dependence on simple rectilinear forms must have attracted Roger Fry, who bought it in 1919. The faint air of melancholy hints at the gloom which often pervades Sickert's images.

HB

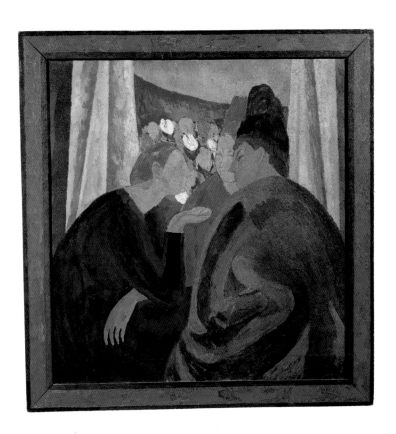

VANESSA BELL
(1879–1961)
A Conversation 1913–19

oil on canvas 86.6 × 81 cm
Gift of the Roger Fry Trustees,
1935

Vanessa Bell was one of the most significant artists in the Bloomsbury Group, a loose assimilation of like-minded writers, artists and art-lovers. This enigmatic painting, framed by the artist herself, shows three women engrossed in conversation against a half-curtained window opening on to a flower garden. The artist later recalled having painted it in 1913, but its style indicates a date immediately after the war. The discrepancy is probably explained by the discovery that the original painting was later reworked. The figure on the left once wore a striped blouse; the curtain behind may have been patterned; the right-hand figure seems originally to have been a seated man holding a cane.

Virginia Woolf, the artist's sister, wrote to her about this picture: ". . . one paean of admiration for your Three Women I think you are a most remarkable painter. But I maintain you are into the bargain, a satirist, a conveyer of impressions about human life: a short story writer of great wit and able to bring off a situation in a way that rouses my envy."

HB

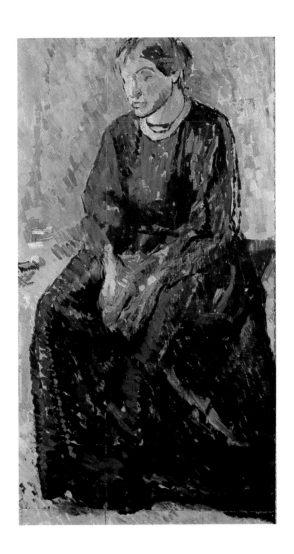

DUNCAN GRANT
(1885–1978)
Seated Woman, Ka Cox
1912

oil on panel 94.8 × 53 cm
Gift of the Roger Fry Trustees,
1935

Ka (Katherine) Cox first met Duncan Grant in 1911, and became
a close friend of several members of the Bloomsbury Group. She was
a member of the 'Neo-Pagans,' who advocated an uninhibited and
simple life, and had a love affair with the poet Rupert Brooke, a leading
figure of the Cambridge 'Neo-Pagans'. She was unconventional, solidly
built, comfortable and kind. To be with her was said to be "like sitting
in a green field of clover". Duncan Grant painted her several times.
Here he has utilized a piece of old wood, perhaps part of a door, on
the back of which he painted a standing male nude.

This portrait was shown at the Second Post-Impressionist exhibition,
organized by Roger Fry in 1912. Grant, often considered the outstanding
British painter of his generation, showed five other paintings there
as well, demonstrating his status as a modern artist inspired by such
painters as Picasso, Matisse and Vuillard. From 1916 Grant lived with
Clive and Vanessa Bell at Charleston Farmhouse in Sussex, his home
until he died.

HB

FRANK DOBSON
(1886–1963)
Reclining Nude 1921–25

white marble
17.8 × 50 × 19 cm
Samuel Courtauld Bequest,
1948

The human figure in repose was the constant source of Dobson's inspiration, and from the 1920s he concentrated on the female nude. His work reflects a range of influences. He had been profoundly affected by Roger Fry's Post-Impressionist exhibition of 1912, where Gauguin's work impressed him more than any other and moved him to study 'primitive' art, an interest extending to the art of India and the Orient. After the war, with Gaudier-Brzeska now dead, Dobson was perceived in England as carrying forward the torch of Modernism, an artistic movement which preferred direct carving, as seen here, rather than modelling in the tradition of Rodin. An increasing classicism, in the style of the French sculptor Aristide Maillol, is evident in this restful nude. Dobson's success was growing, challenging Jacob Epstein's, and in 1925 he was honoured by Roger Fry in his art journal *The Burlington Magazine*, in which the *Reclining Nude* was illustrated. The 1930s saw the eclipse of Dobson's fame by the rise to prominence of Barbara Hepworth and Henry Moore (see pages 88 and 89).
HB

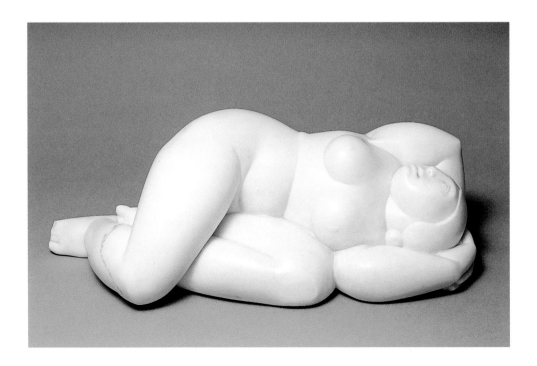

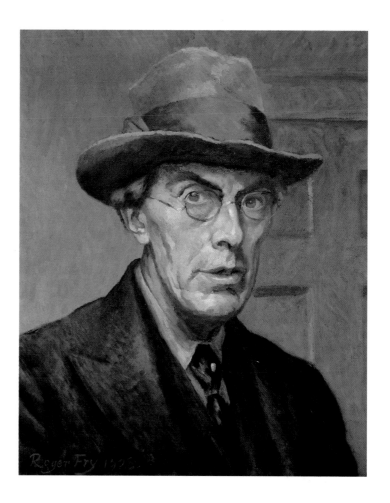

ROGER FRY (1866–1934)
Self-portrait 1928

signed and dated lower left
Roger Fry 1928
oil on canvas 45.7 × 37.1 cm
Bought by the Samuel
Courtauld Trust with
contributions from the
National Art Collections Fund
and the MGC/V&A Purchase
Grant Fund, 1994

Roger Fry was one of the founder-benefactors of the Courtauld
Institute and its collections. He was a man of many parts; there was
enough in his life, according to his biographer Virginia Woolf, to fill
six books. Best-known now as a critic who introduced modern art into
England with the two Post-Impressionist exhibitions mounted in 1910
and 1912, he was also a central figure in the Bloomsbury Group and
the driving force behind the Omega Workshops, which he ran from
1913 to 1919. He was furthermore a collector of ceramics, sculpture and
African and Oceanic wood-carvings, which, along with the collection
of paintings, now belong to the Courtauld Institute Gallery.

Fry's greatest ambition since his early years was to develop his
painting. In spite of his formalist theories, his principal subjects were
landscapes and portraits. There are four known self-portraits. In this
one he paid tribute to Cézanne, for him the "great originator" of
modern painting, modelling it on Cézanne's *Self-portrait* (National
Gallery, London), which he had copied three years earlier.

HB

SAMUEL JOHN PEPLOE
(1871–1935)
Still Life with Jug and Fruit
ca. 1920–25

signed lower right *peploe*
oil on canvas 40.5 × 46 cm
Acquired by the Samuel
Courtauld Trust in 1992 with
the support of the MGC/V&A
Purchase Grant Fund and the
Friends of the Courtauld
Institute of Art

Having studied in Paris in 1894, Peploe returned to France in 1910
and joined the circle of artists around his friend and countryman
J. D. Fergusson. He exhibited at the Salon d'Automne and came into
direct contact with contemporary developments in French art. Although
he was not unaffected by Cubism, it was the free and expressive use
of colour that had the most enduring influence on his work. Peploe
had always been interested in still-life painting and after he settled in
Edinburgh in 1912 it came to dominate his production. In this example
the colours are relatively restrained but the use of bright white gives
the work an unexpected intensity. The objects themselves are typically
modest: a plain jug and some fruit placed on a highly polished table
near what appears to be sketchily painted armchair with drapery.

In 1924 Galerie Barbazanges organized an exhibition entitled *Les
Peintres de l'Ecosse Moderne*, with work by both Peploe and Fergusson
as well as F.C.B. Cadell and Leslie Hunter. Appropriately held in Paris,
it was the first show dedicated to the four painters who would later be
grouped as the Scottish Colourists.

EV

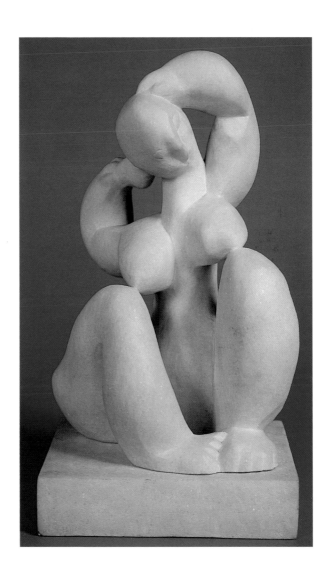

HENRI LAURENS
(1885–1954)
Woman arranging her Hair
(Femme se coiffant) 1946

white marble
height including base 41 cm
Private collection

Laurens was trained traditionally as a stone mason, working on Paris buildings and carving period ornaments. A mature work such as this may therefore be understood both in terms of the expressive grace of France's great stone-carving traditions but also in the context of the radicalism of Laurens's Cubist years, particularly in its rhyming of body parts (here, the angles formed by the knees and elbows) and its expression of volume and depth. Laurens had worked almost exclusively with the seated or reclining nude since the late 1920s. His fantastic contortions of the nude through the 1930s, with tapering limbs and angular dissections, convey the social and political upheavals of those years. Only in the 1940s did he arrive at the restful, composed harmony of these rounded forms, and the completeness he would describe in 1951: "I aspire to ripeness of form. I should like to succeed in making it so full, that nothing can be added."

CP

HENRY MOORE
(1898–1986)
Draped Reclining Figure
1957

bronze, length 73.5 cm
cast of an edition of 11
Fridart Foundation

The majority of Moore's sculptures of full-length figures are recumbent. This enduring preoccupation – "an absolute obsession", to use his own phrase – emerged in Moore's work in the later 1920s. Although they are almost exclusively female, the demeanour of these figures, especially the positions of their heads and shoulders, is more male than feminine. At times their posture recalls that of the Mexican rain-god Chacmool, at others it is reminiscent of river gods, both antique and Renaissance.

Moore was very particular about the way a sculpture sat on the ground: it must not sink down or collapse as if it were on a soft surface; to give it life it had to appear to bounce up. In this example, in which the drapery recalls that of Greek statuary, Moore creates a dynamic tension between the static and organic qualities of the figure, which rests firmly on the wooden block, and the head, which strains upwards. Despite the bronze medium, which Moore began to use in the 1940s, the figure, like his earlier stone or wood carvings, has the sense of having been cut away, the hollowed and cavernous areas between the arms and the body and under the hips allowing interplay between external and internal forms.

This is one of several studies in bronze that Moore made for his monumental marble commission of 1957–58 for the entrance to the new UNESCO building in Paris.

SF

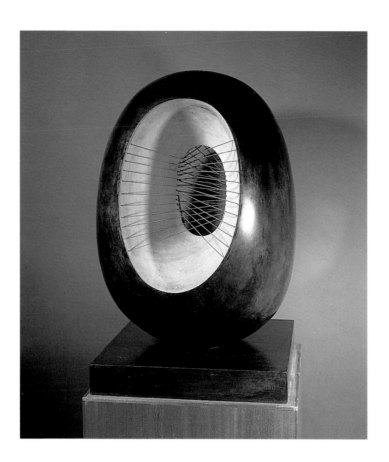

BARBARA HEPWORTH
(1903–1975)
Spring 1966

bronze, height 76.8 cm
cast no. 3 in an edition of 6
Private collection

The simplified organic form of *Spring*, with its painted hollow interior and sensuous polished surface, recalls many of Hepworth's abstract sculptures from the 1930s onwards. The dignified serenity of the ovoid form contrasts with the tension implied by the tightly stretched and intersecting threaded strings. This device, which the artist first used in 1938 in response to the works of Gabo and Moore, links the outer and inner surfaces, creating a penetrable space neither fully closed nor fully open.

Hepworth's interest in the interplay of mass and negative space was first expressed in 1931, when she created an alabaster work, *Pierced Form* (now destroyed), in which a 'hole' was carved through the centre of the sculpture. In the 1960s she was still using the central void to great effect: in this work the softly curving shapes evoke both the female form and the primal landscape of Cornwall, where the sculptor lived from 1939 onwards. During a visit to Hans Arp's studio in Paris in 1932 Hepworth had been inspired by the fusion of landscape with the human form in his biomorphic sculptures. Although by 1935 her work had become entirely abstract, Hepworth always underlined her conscious relationship with landscape and nature. She wrote: "In the contemplation of Nature we are perpetually renewed, our sense of mystery and our imagination is kept alive ... it gives us power to project into a plastic medium some universal or abstract vision of beauty".

SF

BEN NICHOLSON
(1894–1982)
Painting 1937 1937

oil on canvas 79.5 × 91.5 cm
Dr Alistair Hunter Bequest,
1982

Ben Nicholson first experimented with abstraction in 1924 and returned to it with a new sense of purpose in the 1930s. During that decade Nicholson became part of a community of international avant-garde artists and critics based in Paris. In 1933 he and Barbara Hepworth were invited to join the *Abstraction-Création* group, and the following year Nicholson started making the celebrated carved and painted white reliefs which constituted his first major contribution to international modernism. Nicholson continued to produce the reliefs during the 1930s, and they helped establish him as England's most radical Modernist, but he also started to apply his austere non-representational vision to coloured paintings such as *Painting 1937*.

The year 1937 was important for Nicholson and the art that he championed. It saw the exhibition of *Constructive Art* at the London Gallery as well as the publication of *Circle: International Survey of Constructive Art*, an anthology of contemporary architecture, painting and design edited by Nicholson, Naum Gabo and the architect Leslie Martin (who was also the first owner of this painting). London provided a refuge from the growing threat of war in Europe, and with the arrival of figures such as Gabo, Marcel Breuer, Walter Gropius and Piet Mondrian it briefly became a centre of international modernism. Mondrian was particularly influential in Nicholson's development during these years. Nicholson had first met the Dutchman in Paris in 1933 and he experienced the visit to Mondrian's studio the following year as something of a revelation. There is a clear affinity between Mondrian's abstract paintings and works such as *Painting 1937*. However, Mondrian was more doctrinaire and uncompromising in the utopian vision that informed his art, and his paintings appear more severe than comparable work by Nicholson. Whereas Mondrian focused on primary colours and placed them within tight grids, Nicholson's arrangements are softer, more subtle and arguably more intuitive.

Painting 1937 depends on the size, shape, intensity and juxtaposition of various colour planes to generate tension and visual interest. The eye is drawn immediately to the central red square, which helps to organize the experience of the whole picture but also exists in a series of local and very different relationships with each of the colours that borders it, including the now slightly faded yellow. The sense of depth achieved by the visual weight of the coloured planes recalls the spatial effects of Nicholson's white reliefs and the three-dimensional sculptures which he started to produce around this time. Nicholson used a similar range of colours in two other important geometric paintings from 1937 (Tate and Scottish National Gallery of Modern Art). The different qualities of the three works illustrate Nicholson's understanding of the possibilities of geometric abstraction and its power as a mode of expression.
EV

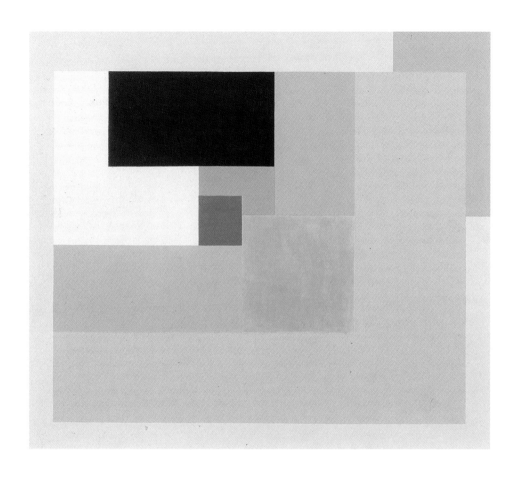

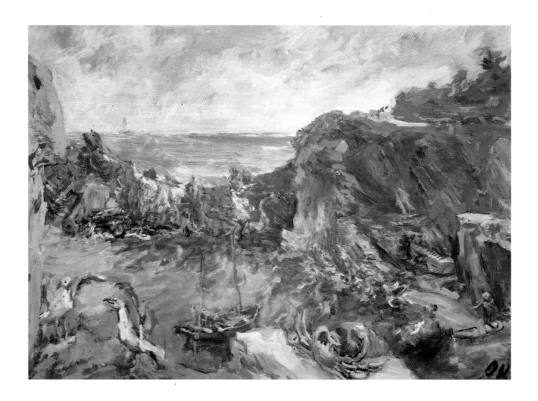

OSKAR KOKOSCHKA
(1886–1980)
Polperro I 1939

signed lower right *OK*
oil on canvas 61.2 × 81.3 cm
Bequeathed as part of the
Princes Gate Collection, 1978

In August 1939, following his flight from Prague and shortly before the outbreak of World War II, Kokoschka and his future wife, Olda, moved to Polperro, a Cornish fishing village. They lived at Cliff End Cottage, and from his terrace overlooking the harbour Kokoschka painted this scene twice in oils (*Polperro II* is in the Tate) and in a series of watercolours. Across the outer harbour is the rocky headland, a natural breakwater known as the Peak; to the right is Chapel Cliff, already by then National Trust property. After the fall of France foreigners were banned from coastal districts and Kokoschka returned to London.

The crab seen here in the foreground reappears as principal subject, with Polperro forming the background, in a third oil (Tate), painted after war was declared. There it assumed explicit political symbolism: Kokoschka explained, "This is Chamberlain after Munich He says 'Uah! What have I done!'" In this painting, in the lower right corner, a woman appears to be mourning over a prostrate body, perhaps another comment on the Munich Agreement.

HB

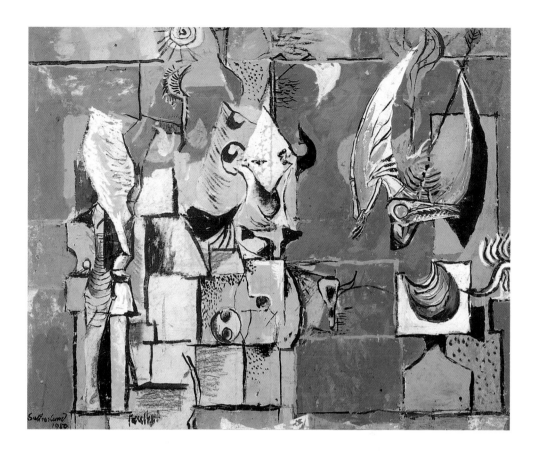

GRAHAM SUTHERLAND
(1903–1980)
Study for *The Origins of
the Land*, 1950

signed and dated lower left
Sutherland 1950
gouache, pencil and crayon
on paper, laid down on board
53.6 × 67.5 cm
Dr Alistair Hunter Bequest,
1982

The Origins of the Land (now in the Tate) was commissioned from
Sutherland for one of the pavilions of the Festival of Britain, held on
London's South Bank from 4 May to 30 September 1951. Sutherland
executed a large number of preliminary studies for the work, using
these to explore themes and plan the composition. Whereas in this
example the composition is organized in horizontal strata, the finished
picture is vertical, measuring over 4 meters in height. Sutherland
described *Origins of the Land* in 1957: ". . . broadly speaking the picture
is divided in sections through the crust of the earth It is as if you
were looking at a cliff face." The pterodactyl at the right was intended
to suggest prehistory. The small strip at the top shows the surface of
the earth and the sky with a schematic sun. The reverse side of the
board on which this work is pasted has a detail of a Crucifixion, which
may be related to the monumental image of the *Crucified Christ* that
Sutherland painted for St Matthew's Church in Northampton in 1946.
EV

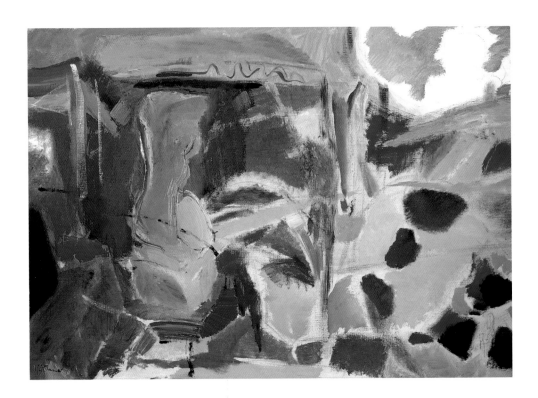

IVON HITCHENS
(1893–1979)
A Sybilline Courtyard 1974

signed lower left
oil on canvas 71.2 × 101.6 cm
Dr Alistair Hunter Bequest,
1982

In 1940 Ivon Hitchens moved from London to the countryside near Petworth in West Sussex, where he lived and worked for the following four decades. Although he had previously experimented with abstraction and many of his works initially appear to make little reference to the visible world, Hitchens invariably painted in front of his subject and he worked on his predominantly horizontal landscapes out of doors. Here a sculpture on a square plinth can be identified by the edge of what appears to be a circular fountain.

Rather than seeking to transcribe visible reality, Hitchens's rich colour harmonies and distinctive brushwork record and transmit a broader sensory experience of nature. Describing his paintings as "visual sound", he said, "My pictures are painted to be listened to".

This is one of five paintings by Hitchens bequeathed to the Courtauld by Dr Alistair Hunter. The bequest has at its core British painting from the 1960s and 70s and includes work by Prunella Clough, John Hoyland, Patrick Heron and Keith Vaughan.

EV

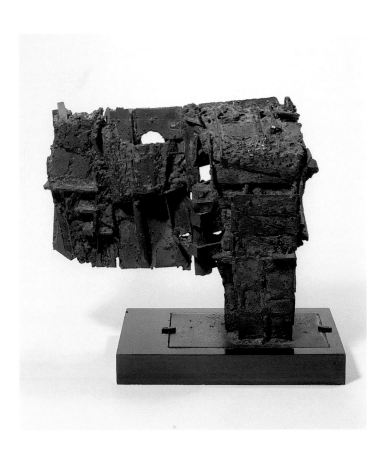

CÉSAR
(CÉSAR BALDACCINI,
1921–1998)
Winged Figure: 'Habitation'
1960

welded iron and steel;
industrial objects
32 × 37 × 14.8 cm
Dr Alistair Hunter Bequest,
1982

The title of this single-winged figure, *Habitation*, remains unexplained. The compressed material incorporates industrial objects, such as bolts, screws, piping and brackets. This is typical of César, who claimed that he used the scrapheap because he could not afford sculptor's materials. However, the practice followed naturally from the art of *objets trouvés* ('found objects'), and coincided with that of the French '*Matiéristes*' and the Italian '*Arte Povera*' artists, whose coarse materials were sanctified as morally necessary. César's '*nouveau réalisme*' (new realism) aimed at making art look accidental. In 1960, the year of *Habitation*, he produced a crushed automobile, his celebrated *Compression*.

In his day César was France's best-known contemporary sculptor, a 'celebrity', his position based as much on self-promotion as on the scale and audacity of his work, including a twelve-metre-high thumb at La Défense in Paris and a 520-ton wall of wrecked cars at the 1995 Venice Biennale. Progressing from impoverished rebellion to worldly success, he designed the 'César', a French equivalent of the Hollywood 'Oscar', and gold and diamond jewellery perversely simulating scrap metal.

HB

Index of Artists